RODIN and CAMILLE CLAU W9-CAE-219

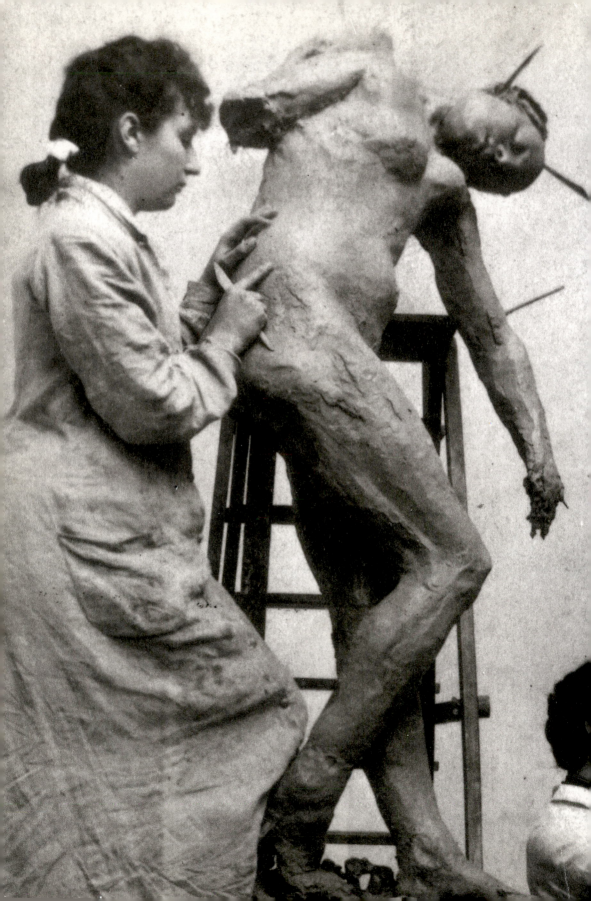

J.A. Schmoll gen. Eisenwerth

RODIN
and
CAMILLE CLAUDEL

Prestel

Munich · New York

In memory of Wilhelm Loth (1920–1993),
sculptor of female torsos and idols

© Prestel-Verlag, Munich · London · New York, 1999
© of all works by Camille Claudel: VG Bild-Kunst, Bonn 1994

Translated from the German by John Ormrod
Copyedited by Anne Heritage

Front cover: *The Eternal Idol*, 1889 (detail; see p.45), Musée Rodin, Paris
Back cover: *Head of the Martyr* (Tête de la martyre), 1885 (detail),
Musée Rodin, Paris
Frontispiece: Camille Claudel working in Rodin's studio,
ca. 1888, Musée Rodin, Paris

Prestel-Verlag
Mandlstrasse 26, 80802 Munich, Germany
Tel. (89) 38 17 09-0; Fax (89) 38 17 09-35
4 Bloomsbury Place, London WC 1A 2QA, England
Tel. (0171) 3 23 50 04; Fax (0171) 6 36 80 04
and 16 West 22nd Street, New York, NY 10010, USA
Tel. (212) 6 27-81 99; Fax (212) 6 27-98 66

Lithography by Fotolito Longo, Frangart, Italy
Typeset, printed and bound by Passavia, Passau
Typeface: Clearface
Cover design: Matthias Hauer and Meike Weber

Printed in Germany

ISBN 3-7913-2005-X (paperback)
ISBN 3-7913-1382-7 (hardback)

CONTENTS

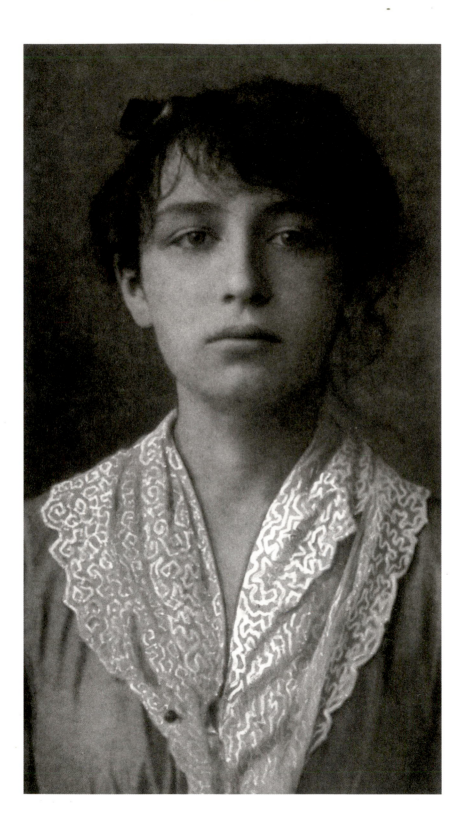

The Tragedy of Camille Claudel

An extraordinary fascination has come to surround the life of Camille Claudel, the sculptor who was Auguste Rodin's pupil, collaborator, muse, model, and lover. Having fallen into a state of lonely, unproductive misery and paranoid confusion after the couple separated, she spent the last thirty years of her life locked away in a psychiatric hospital. Assiduous efforts have been made to collect and classify the body of work that Claudel left to posterity, comprising originals and reproductions of sculptures in plaster, bronze, and marble, together with a number of drawings and paintings. Moreover, a succession of commentators have reconstructed her biography, examined her character and medical history in the search for an explanation of her terrible fate, and endeavored to evaluate her relatively slender, but significant, oeuvre. In accordance with the view of her contemporaries, it is generally accepted that her work as a sculptor was heavily influenced by Rodin from the time when she first became his pupil in 1883 until well after their separation. However, it is more difficult to assess the extent of her contribution between 1885 and 1892, when she and Rodin were living together and working in close collaboration, and to arrive at a balanced appraisal of the works she produced after the collapse of their relationship, when she was trying to move out from under Rodin's shadow and establish herself as an independent artist in her own right. A number of writers—notably Reine-Marie Paris, Renate Berger, Renate Flagmeier, Françoise de Varennes, and the novelists Anne Delbée and Barbara Krause—have made concerted attempts to emphasize the originality of Claudel's sculpture. It is understandable that those who have taken up the cause of defending women against oppression and abuse by a male-dominated society would seek to rescue Claudel from obscurity and vindicate her artistic reputation. Perhaps excusably, this has involved a certain amount of exaggeration in setting her work apart from that of Rodin and garlanding it with enthusiastic praise. She is seen as a genius who failed to achieve due recognition, and, furthermore, as Rodin's victim. Based as it is on contemporary estimations of Claudel's art, this view is not wholly without foundation. However, the words of praise quoted in her favor are generally brief, and the majority of the critics in question were members of the coterie that accompanied Rodin on his path to fame. Even after the end of the affair, they were cajoled or even bullied into commenting approvingly on her work. And one is hardly surprised by the lyrical tributes of her brother, the poet and diplomat Paul Claudel. In the interests of objectivity, the significance of these fraternal gestures should not be overestimated.

Camille Claudel,
ca. 1884

Now that we know more about Camille Claudel's work, the moment has surely come to subject it to renewed scrutiny. This is the purpose of the following portrait, which does not pretend to be exhaustive, but sets out the principal features of the case in as much detail as necessary. Deviating from the approach taken in previous accounts, several points have been added or given particular emphasis: the work of Rodin, which is often willfully undervalued or not treated in sufficient breadth; the frequent misrepresentation of the collaboration between Rodin and his assistants; and the specific character of Claudel's work in the light of its relationship to the upsurge of interest in the decorative or applied arts in the 1890s. The latter aspect not only indicates the need for a reevaluation of her later work; it also points to an internal conflict of aims that undoubtedly contributed to her creative crisis. This, in turn, was amplified by the personal crisis that overtook her when she and Rodin parted company and by the periodic bouts of persecution mania to which she became increasingly subject.

The case of Camille Claudel and Auguste Rodin has recently attracted a great deal of attention. Over the last ten years, a spate of exhibitions, biographies, novels and films has gradually brought the tragedy of Camille's

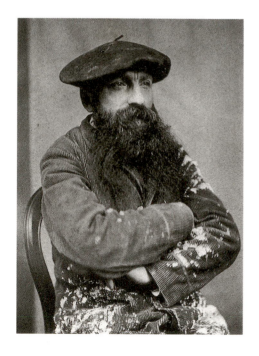

Auguste Rodin,
ca. 1880

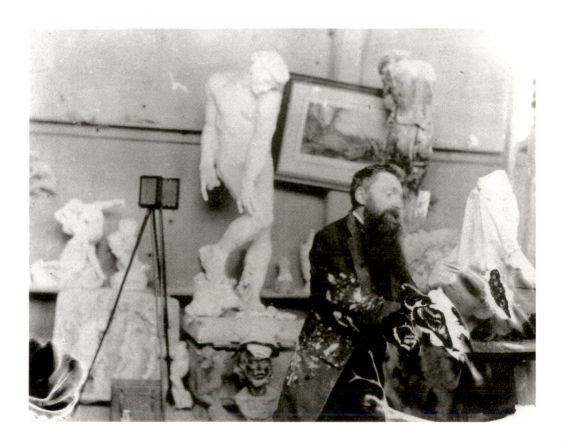

Auguste Rodin, ca. 1885. In the background the plaster maquettes of *Eternal Springtime* and *Adam and Eve*

life to the notice of the general public. However, it is mistaken to imagine that her fate has only now been uncovered. The events in question, which took place a century ago, were known at the time and much discussed in the intellectual and bohemian circles of fin-de-siècle Paris, although references in print were mainly limited to veiled allusions. The great Norwegian dramatist Henrik Ibsen used the story as the basis for his last play, the tragedy *When We Dead Awaken*, which received its premiere in 1899. Thinly fictionalizing the main actors in the real-life drama, Ibsen cast Auguste Rodin in the role of the famous sculptor Arnold Rubek (even the initials are the same), while Camille Claudel appears as Rubek's young and beautiful model, Irene, who has suffered a mental breakdown. The discrepancies between the action of the play and the reality of the relationship between Claudel and Rodin have led to accusations that Ibsen failed to research the details of the affair with sufficient thoroughness. This is preposterous: Ibsen was an imaginative writer, not a journalist, and he used the leitmotiv of the reports that reached him from Paris to create a social drama suffused with symbolism that follows its own specific logic.

9

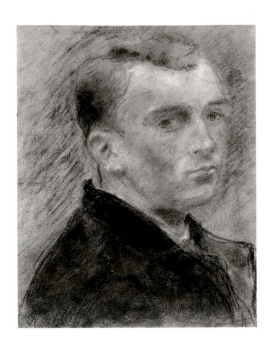

Camille Claudel,
*Portrait of Paul
Claudel*, 1888

And, in fact, the central theme of the play was lifted almost straight from life. Irene, who adores Rubek just as Camille loved Rodin, realizes that the artist's emotional energies are reserved entirely for his own work; instead of loving her for her own sake, he sees her as merely a model for his chef d'oeuvre, a statue of a woman in a work with the title *Resurrection*. Out of her mind with despair, she is temporarily confined in an asylum. After her release, she and Rubek meet again by chance, and a brief period of false euphoria ensues. After setting out to climb a mountain that symbolizes their desire to ascend once again to the heights of passion, the sculptor and his model are killed by an avalanche. At the time when Ibsen wrote his play, the tragedy of Camille Claudel had not yet reached its climax, or, to put it another way, its nadir. It was not until thirteen years later that she was interned in the mental hospital where she was to spend the remaining thirty years of her life.

During the inter-war period, few people were aware of Camille Claudel and her art, which was known only to a handful of connoisseurs and members of Rodin's personal circle of artist-friends. As far as the general public was concerned, she had practically vanished from the face of the earth. The first retrospective of her work took place at the Musée Rodin in 1951, eight years after her death, at the age of seventy-nine, in the Montdevergues asylum near Avignon in the south of France. Organized by Cécile Goldscheider under the supervision of Marcel Aubert, the exhibition filled

two rooms at the Palais Biron. It was held partly in response to Rodin's proposal, put forward at the instigation of Mathias Morhardt when the sculptor was making his will, that the work of his former pupil be placed on permanent display in the museum devoted to his own oeuvre. At the same time, the show also fulfilled a long-felt wish on the part of her brother, Paul, whose illustrious status as a poet and member—since 1946—of the Académie Française made him impervious to the pitying disdain in which his mentally afflicted elder sister was held. He took the opportunity afforded by the exhibition to write a glowing tribute to Camille, which appeared in the catalogue booklet, together with a hate-filled tirade against Rodin, her "seducer," who had supposedly driven her into psychological breakdown. At the time when Paul Claudel published this vitriolic attack, four years before his own death, the Paris art world did not respond

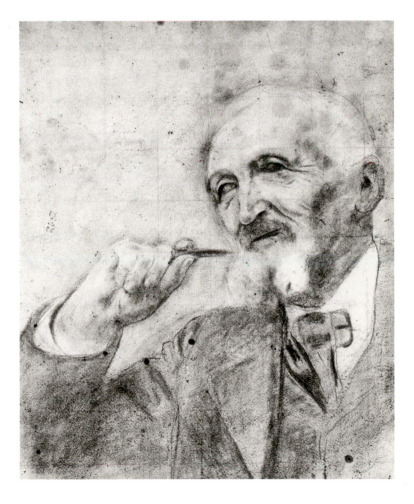

Camille Claudel,
*Portrait of Louis-
Prosper Claudel*,
1905

with anything like the degree of excitement it showed thirty years later. The essay was seen as Claudel's personal, subjective reaction to his sister's sad fate, and there were murmurings to the effect that he was trying to exorcize his own feelings of guilt.

Subsequently, however, society's ideas about the role of women underwent a fundamental transformation, and a very different reaction ensued when the next major retrospective was staged in Paris in 1984. This was quickly followed by several further exhibitions—for example, in Bern, Hamburg, and Martigny—accompanied by a whole series of academic and literary publications, and by the highly emotive film of Camille's life starring Isabelle Adjani in the title role. In a changed climate of opinion, Camille Claudel seemed to offer a classic example of a woman artist who had been oppressed and abused by a more successful man. According to this interpretation, Rodin had exploited her affections and talents and then promptly dropped her when she threatened to become a nuisance. Following a familiar pattern, almost to the point of cliché, her story was seen as an object lesson in the evils of patriarchy. But this reading of the tale raises a number of questions regarding the details and context of the events concerned. What, for example, of Camille's childhood background and the distribution of roles within the family? How did she relate to her mother, her father, her sister, and brother? How did Rodin really behave toward her? To what extent did her innate mental instability contribute to her eventual breakdown? And finally, what is the true value of her work as an artist? These are some of the questions we shall be endeavoring to answer.

Camille Claudel's Family and Youth

Camille Claudel was born on December 8, 1864, in Fère-en-Tardenois, a small town situated between Reims, Soissons and Château-Thierry in the Champagne region of France. Her father, Louis-Prosper Claudel, was a native of Lorraine and owned a small house near Géradmer, a popular center for tourists visiting the Vosges mountains. The son of a civil servant, Louis-Prosper Claudel had received a sound classical education at the Jesuit school in Strasbourg and accordingly built up a considerable library that was available for use by Camille and her equally knowledge-hungry brother, Paul. His own government service career took him from the position of revenue inspector to the relatively elevated office of a registrar of mortgages, which involved frequent transfers from one district to another. It was in Fère-en-Tardenois, by the little river known as the Ourcq (the scene of the second, bloody battle of the Marne in 1918, which destroyed a substantial part of the property owned by Camille's mother) that Louis-Prosper Claudel met his future wife, Louise-Athénaïse Cervaux, whose father, a doctor, was the mayor of Villeneuve-sur-Fère, a small community just over two miles away. When the couple married in 1861, their respective inheritances added up to a tidy fortune in real estate. The Cervaux family home opposite the village church in Villeneuve is still standing today. Camille's brother, the poet Paul Claudel, was born here in 1868, in a small outbuilding which now belongs to the rectory, and the spacious house became the main residence of the Claudel family, which was temporarily domiciled in a variety of other places, including Paris, but invariably returned to Villeneuve during the vacation season. Having lost her own mother (a member of the Thierry family from the Champagne region) at the age of four, Louise Cervaux Claudel evidently lacked experience of genuine maternal warmth. Villeneuve was not only her birthplace but the source of her self-esteem as a person of considerable local standing—the daughter of the doctor and mayor, and sister of the village priest. She found the life of a bourgeois country housewife entirely fulfilling, and was unable even to imagine any deviation from the traditions that had governed her own upbringing. Although she temporarily appeared to relax her stern views, she never accepted Camille's choice of career. She soon came to regard her daughter, a wild and unruly child with an over-fertile imagination, as a cuckoo in the nest, a falcon among sparrows, an accident of nature that broke the provincial mold. Of her three children—as well as Paul, there was also a younger daughter, Louise—she loved Camille the least, finding her willfulness and often arrogant, domineering manner especially irksome. As Camille grew

up, her beauty became ever more marked. Apart from her figure, her deep-blue eyes and chestnut hair were particularly striking, although the overall effect was marginally impaired by her weak chin, apparent in profile, and slight limp, the result of a congenital hip defect. Seen full-face, the attractiveness of her features was enhanced by the boldness of her expression, as captured in the well-known portrait by the Paris photographer César. This picture, taken in 1884 when she was aged nineteen, is the classic document of her youth: a psychologically acute study of a ravishingly beautiful but deeply enigmatic young woman.

Like many other artists who subsequently found fame, Camille Claudel discovered her gift for clay modeling at a very early age—even, it seems, before she began to draw. Auguste Rodin, the greatest modeling genius of his day, showed the same precocious liking for clay, a material whose softness and malleability appeal to our tactile instinct to discover and shape the world. It was this biographical parallel, or coincidence, that subsequently brought Claudel and Rodin together, as a couple whose lives appeared to be linked by fate. For the moment, however, such a prospect seemed highly unlikely. Camille and her family regarded modeling as a mere childish pastime, and the decision to turn it into a professional occupation, by studying sculpture, still lay many years ahead.

Shortly before the battle of Sedan and the fall of the Second Empire in 1870, Louis-Prosper Claudel was transferred to the small town of Bar-le-Duc. It was there that Camille first went to school at the age of six; later, the children were taught at home by a private tutor. Until the age of twelve Camille lived in Bar-le-Duc, a town noted for the famous "skeleton" in the Eglise de St. Pierre. When René de Châlons, the Prince of Orange-Nassau, was killed in battle in 1544, his widow erected an unusual monument to her former husband: a gruesome statue of Death, portrayed as a semi-skeletal figure with a few remaining scraps of skin and tissue clinging to its otherwise bare bones. In the pose of a living man, he holds up his own intact heart (originally, the dead Prince's actual heart, enclosed in a precious capsule) in his outstretched right hand. The gesture symbolizes the Prince's claim to eternal life, as a believer in the Resurrection, and thus defies the crumbling of his mortal flesh. This limestone figure, made by the noted local sculptor Ligier Richier, the "Lorraine Michelangelo," doubtless made a strong impression on the imagination of the young Camille, with her early interest in sculpture. We shall be returning to it again later.

In 1876 Camille's father was transferred again, to Nogent-sur-Seine, the sub-prefecture of the Aube *département*. This change of scene brought Camille closer to Paris: situated in the Champagne country, Nogent-sur-Seine is only about sixty miles from the French capital. It was here, too, that

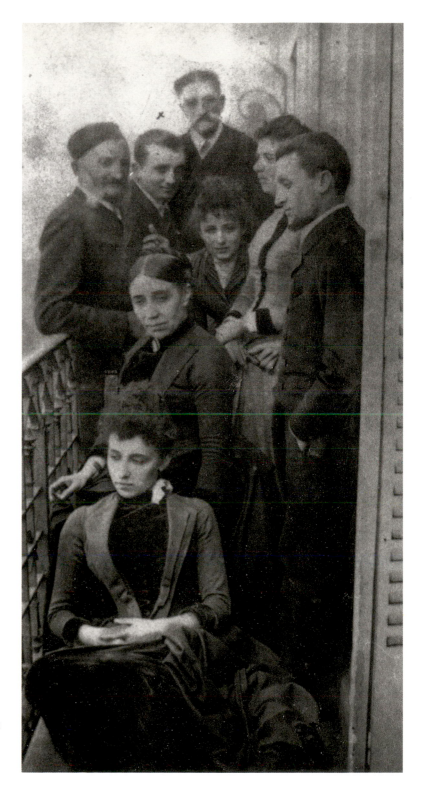

The Claudel family
on the balcony of their
apartment in Paris.
Camille pictured in
the center, to her left
her brother and father;
seated before her,
her mother and sister
Louise

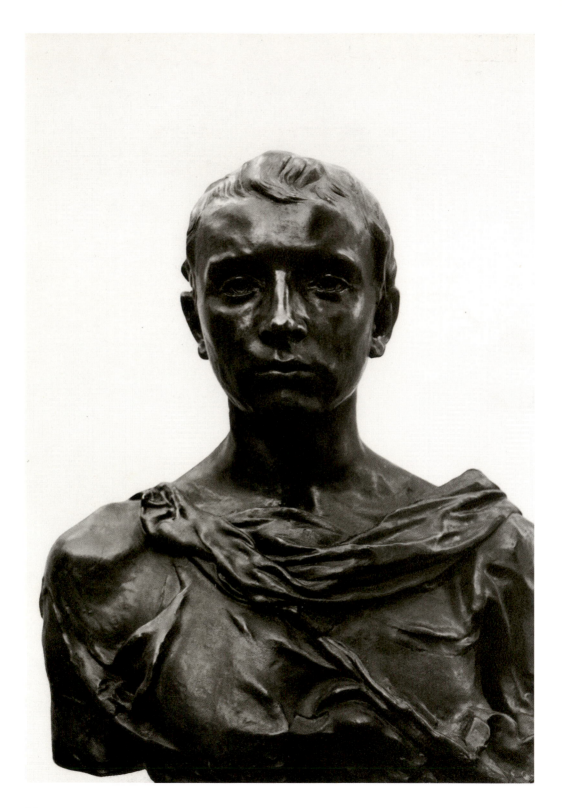

Camille made what were probably her first significant sculptures: a bust of Napoleon (who had set up his headquarters in Nogent for several days while fighting the rear-guard actions that accompanied his retreat in February 1814), a bust of Bismarck (the great opponent, and vanquisher, of Napoleon III) and a group of figures based on the story of David and Goliath. These early works are mentioned in various records but have all been lost.

Nogent-sur-Seine was also the home of two significant nineteenth-century sculptors, whose memory is still preserved today by the town's museums and monuments: Paul Dubois (1829-1905), who in 1878 was appointed Director of the Ecole des Beaux-Arts in Paris, and Alfred Boucher (1850-1934). This contact had a considerable importance for the future. Camille's father was not entirely convinced of his daughter's abilities, and in 1879 or thereabouts, he asked Boucher for an opinion of her work. Astonished by the fifteen-year-old Camille's proficiency, Boucher encouraged her father

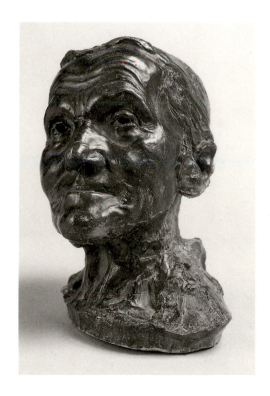

Camille Claudel,
*Young Roman
(My Brother at Age
Sixteen)*, 1884

Camille Claudel,
La Vieille Hélène, 1882

to let her pursue her interest in sculpture on a serious basis and strengthened her resolve by praising her work and giving her a certain amount of practical help. At this point, women were still barred from studying at the Ecole des Beaux-Arts, but there were several private art schools in Paris that admitted female students. It seems likely that Boucher introduced Camille to Paul Dubois, his own teacher at the Ecole, and subsequently, with the backing of Dubois, recommended that she attend the Académie Colarossi. In 1879 or 1880, her father had to move once more, this time to Wassy-sur-Blaise in the *département* of Haute-Marne, which was further away from Paris. At Camille's wish, and for the sake of the children's education, he rented an apartment for the family in Paris, on boulevard Montparnasse. For him, this was the start of an extended period of commuting back and forth between Paris, Wassy, and—during the holiday season—Villeneuve.

Paris was the focus of Camille's youthful hopes and yearnings, as the city that held out the greatest promise of making her artistic dreams come true. Her brother, Paul, four years her junior, was sent to one of the capital's elite lycées, an institution that initially filled him with dread: like his mother and younger sister, Louise, he preferred life in Villeneuve. However, he gradually found his way into the metropolitan intellectual milieu that was to determine the course of his future. His fellow students at the school included André Gide and Marcel Schwob.

In 1881, before even reaching her seventeenth birthday, Camille entered the Académie Colarossi. There, she soon fell in with a circle of young women sculptors—including three Englishwomen—who shared a studio in the Rue Notre-Dame-des-Champs, where they received a weekly visit from Alfred Boucher, who corrected their work and gave them the benefit of his general wisdom. Camille rapidly advanced to the position of spokeswoman for the group. Knowing Boucher from Nogent, she was familiar with his teaching style and technical approach. At this point she began to address herself in earnest to making portrait studies. Her first extant works date from 1881: a plaster bust of the goddess Diana (now owned by a private collector), and a bronze bust of her brother, aged thirteen (purchased by Baron Alphonse de Rothschild and donated to the Musée Bertrand in Châteauroux). A year later, she made her terracotta head of *La Vieille Hélène*, the Claudel family's housekeeper in Villeneuve, Nogent and Paris. The carefully observed head is starkly naturalistic in style, showing all the lines and wrinkles of the aged woman's face. In contrast, the later bust of her brother at the age of sixteen strikes a kinder note: the figure, in the posture and costume of a young Roman, is mildly idealized, and the folds of the tunic falling over his upper arms and chest are finely detailed. One senses the

possible influence of Boucher. In 1883, however, Camille's teacher moved to Italy to take up the greatly coveted Prix de Rome scholarship at the French Academy. He appointed Auguste Rodin, a close acquaintance, to take his place as mentor to Camille and her fellow students at their regular Friday tutorial gatherings. This brought Camille Claudel and Auguste Rodin together for the first time, in a relatively informal pupil-teacher relationship.

Rodin's Rise to Genius

While Camille had yet to reach her nineteenth birthday, Rodin, born on November 17, 1840, was forty-three years old. (Since their respective birthdays fall at the end of the year, the couple's ages tend to be overstated, but the discrepancy still amounts to twenty-four years.) Rodin had seen a long period of arduous labor and hurtful disappointments. His sculptural talents, especially his gift for modeling human figures and faces, had been recognized at an early age and exploited to the hilt by decorators and commercial sculptors for some twenty years, at first in Paris and then—after the end of the Franco-Prussian War, in which he served briefly as a sergeant in the pioneer corps—in Brussels, where he found employment with the French commercial sculptor Albert Carrier-Belleuse, who was living in Belgium, and with the latter's business partner Van Rasbourgh. As well as making ornamental figures for several major buildings in Brussels, such as the Bourse and the Palais des Académies, he had worked on the monument to Jean-François Loos, the former mayor of Antwerp, and designed façade decorations for a number of private houses. These various activities were sufficiently well-paid to finance a semi-bourgeois lifestyle, and they enabled him, at least in part, to travel for the first time to Italy—an important step in his development. However, his commercial work could not satisfy his artistic ambitions. He returned to Paris in 1877 with his first major sculpture, the statue that later became known as *The Age of Bronze*.[1] The work, showing the figure of a young man emerging from misery and depression into a new state of heightened awareness, initially came under heavy attack from critics and fellow artists alike, who claimed that the figure had been made with a plaster cast taken directly from a living person. Rodin was deeply hurt by this allegation, which offended his artistic pride. Eventually his reputation was restored, and the work was purchased by the French

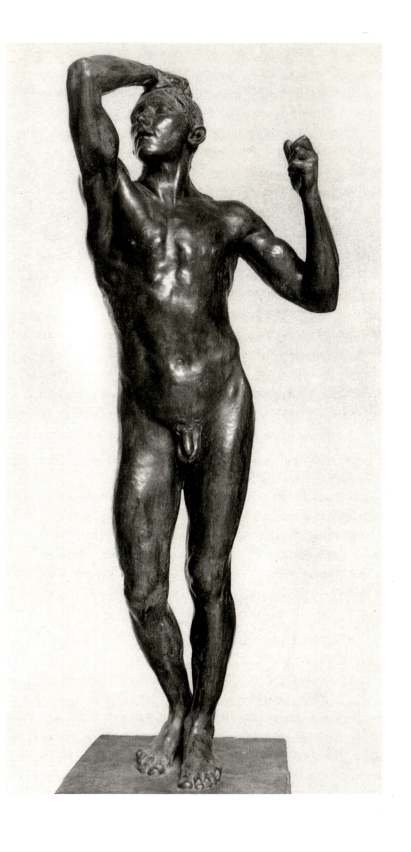

government, which paid for the first bronze cast of this piece and also of his second statue, a version of St. John the Baptist seen as an emaciated yet muscular figure striding through the wilderness preaching. Subsequently, in 1880, Rodin received a government commission to make a door for the projected Musée des Arts Décoratifs. The terms of the commission specified that the door was to be executed in bronze, with an elaborate relief pattern, but the choice of theme was left to the artist. Rodin had been in a state of creative turmoil for several years, ever since his journey to Italy in 1875-76, when he first saw Michelangelo's *Last Judgment* in the Sistine Chapel. Like his great Florentine predecessor, he had been deeply moved by the descriptions of the Inferno in Dante's *Divine Comedy*, which he read over and over again in a French translation, often carrying the book around on his person. From 1880 onward, he labored obsessively on the sketches for the bronze door, little suspecting that this same work—later titled *The Gates of Hell*—would continue to occupy him until 1917, the year of his death. It was to become his magnum opus. In *The Gates of Hell*, Rodin brought together every variety of human suffering and passion. He graduated ever further away from illustrating Dante's epic poem: only vague traces of his original source of inspiration are to be seen in the figures—over two hundred in number—that populate the relief sections and the outer framework. The residual allusions to the *Divine Comedy* are overlaid by other literary references, notably to Baudelaire's *Les Fleurs du mal*. Like many of his contemporaries, Rodin regarded Baudelaire's symbolist poetry as a latter-day equivalent of Dante's medieval vision of hell, addressing the crucial human issues of sexuality and death with a new power, profundity and beauty that Rodin found personally disturbing and moving. The sense of inescapable fate in the human urge to embrace life and love, in the knowledge that such surrender can only lead to disaster—this typically Baudelairean theme weighed heavily on Rodin's mind and posed a supreme challenge to his creative powers.[2]

When he first encountered Camille in 1883, Rodin had reached a decisive stage in his preparations for *The Gates of Hell*. Although its form was still provisional, the outlines of the finished work were already visible; figures, fragments, and groups for the project were pouring from the sculptor's hands. In the same year Rodin made a portrait of Victor Hugo. This formed the basis for several subsequent projects and for the well-known monument originally located in the gardens of the Palais Royal. Hugo's epic poetry thereupon became part of the tissue of literary associations surrounding Rodin's conception of hell, which amounts, quite simply, to a vision of life, with its eternal conflict between the promptings of desire and the wish to escape the suffering entailed by yielding to temptation.

Auguste Rodin,
The Age of Bronze,
1876

This aspect of Rodin's work and ideas has to be borne in mind when considering the beginning of his relationship with Camille Claudel. Who was the person Camille encountered when her new teacher appeared on the scene, and what did Rodin see in his young and tempestuous pupil? Was there a *coup de foudre*, an immediate sense of a meeting with destiny? No one knows exactly, but it is likely that the mutual attraction blossomed very soon. Camille must have been aware from the outset that the foremost artist in her chosen field had stepped into her life. Although Rodin appeared in the guise of a mere instructor, coming to correct the work of a group of young ladies, it was obvious that he was worth far more than Boucher and Dubois put together—not an academic sculptor, but an enigmatic genius whose hands, kneading the clay at lightning speed, could instantly create the most complex and expressive forms. This man had to be the master who could finally provide Camille with a proper set of artistic bearings.

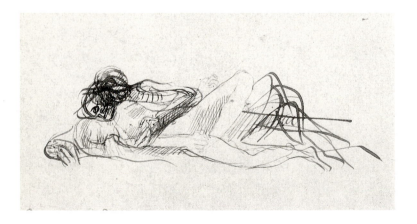

Auguste Rodin,
Skeleton Embracing a Reclining Woman,
ca. 1885. Inspired by Baudelaire's poem "Une Charogne" from *Les Fleurs du mal*

Auguste Rodin,
The Gates of Hell,
1880-1917

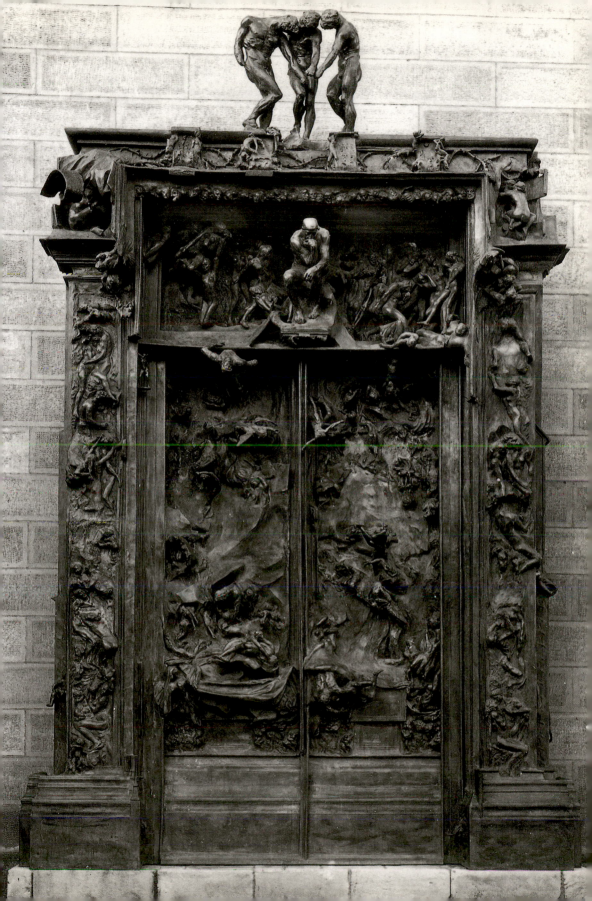

Rodin and Camille Claudel

In the course of the following year, the couple's acquaintance steadily deepened. In 1884 Rodin made his first portrait bust of Camille, an austerely beautiful head with large eyes, short hair and sharply defined features (bronze cast in the Musée Rodin, Paris). The attraction grew ever stronger. In 1885 Camille exhibited her first work, the head of *La Vieille Hélène*, and at the end of the year she accepted Rodin's invitation to come and work at his studio with her English friend Jessie Lipscomb. After her death, a number of letters and telegrams from Rodin were found among Jessie Lipscomb's papers, but Camille's letters were either lost or destroyed. Rodin's letters show the depth of his feelings for Camille: his interest had evidently progressed well beyond the mere admiration of her facial beauty that had led him to model the portrait bust of the previous year. Thus, for example, he writes begging for "news of Mlle Camille"[3] and regretting that "you [i.e. Jessie] did not come last night and could not bring our dear stubborn one: we love her so much, and it is she, I do believe, who leads us. I thank you for the ardent and discreet affection you bear her."[4]

By 1886, Rodin was so smitten with Camille that he followed her all the way to England, where she was spending the summer with Jessie Lipscomb and her family in Peterborough. It would seem that Camille had once again rejected Rodin's advances and taken up the Lipscombs' invitation in order to get away from a relationship that she doubtless found upsetting and which may already have had delicate consequences—although this point is uncertain.

Rodin's efforts to see Camille in England were in vain. Staying in London, he wrote one letter after another to Jessie Lipscomb, asking her to put in a good word for him. He complained of the "overwhelming sadness" that had accompanied him from Paris to the chilly shores of Britain, and warned Jessie: "Make sure that your little Parisienne does not suffer from the cold." In a subsequent letter he told her: "I have written to Mlle Camille....Continue to plead my cause, even though it may be hopeless: if she says yes, telegraph me."[5]

Rodin then wrote to tell Camille that he had intervened on her behalf to persuade his acquaintance Léon Gauchez, the editor of the prominent magazine *L'Art*, to publish one of the customary line drawings of her most recent sculpture. She thanked him but continued to keep him at arm's length. Finally Jessie Lipscomb talked her parents into inviting Rodin to visit the family home in Peterborough. Reunited under the same roof, the couple saw each other continually, but Camille remained aloof and irritable.

Auguste Rodin,
Embrace, ca. 1885

She ruthlessly inflicted her moods on the company. On one occasion, for example, she rudely broke up a musical evening at which Jessie was singing Scottish ballads. Rodin was depressed by this, and his disappointment continued to echo through his later comments on the episode. At the end of August he traveled back to France, hoping for a meeting with Camille and Jessie in Calais so that he could take them on a brief tour of Belgium, which he knew so well from his stay there in the 1870s.

Rodin's plan failed. Nevertheless, before she left England, Camille wrote him a significant letter—one of the few pieces of correspondence from her that was found in his estate—in which she adopted a more conciliatory tone: the usual peevish criticism is leavened by friendliness. The letter ends thus: "I'll write you the day of my departure from England. From now until then, please work, and save all the fun for me. A fond embrace, Camille."[6] This, at least, was something.

It should be remembered that during the same period—from 1884 to 1887—Rodin was extraordinarily productive. *The Gates of Hell* continued to grow, and made huge demands on his energies. Yet at the same time, he made a series of superb portrait busts: the bust of his fellow sculptor Jules Dalou, in particular, is one of the century's most impressive examples

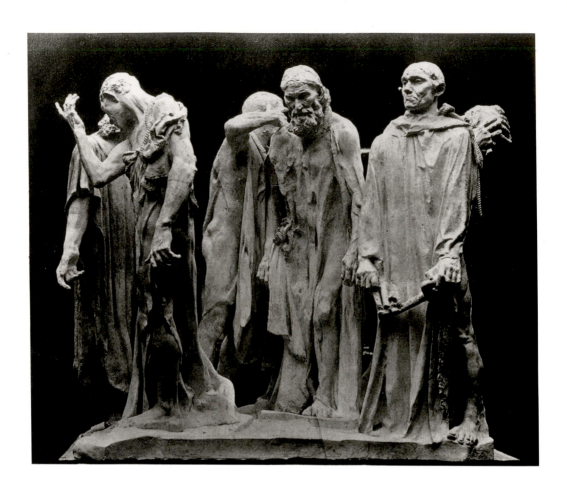

Auguste Rodin, *The Burghers of Calais* at Georges Petit's gallery, 1889

of portrait sculpture. And in the fall of 1884, he was commissioned to design the monument to *The Burghers of Calais*, which was to become one of his major works. He wrestled tenaciously with the theme and form for several years, and the outcome, with its democratic treatment of the figures, was a milestone in the development of monumental sculpture.

Much store has been set by the reports that Camille, in her capacity as an assistant in Rodin's studio, also worked on the modeling of the feet and hands for this remarkable monument to the six citizens who offered their own lives to save the town of Calais in 1347. The significance of this has been exaggerated in order to emphasize Camille's role in the creation of the work. At the time, it was customary to entrust such relatively minor tasks to talented assistants and to incorporate the results, provided that they were successful, into the finished sculpture. But the artist's responsibility for the work as a whole also extended to its parts, and it was he who

had to select the ready-made pieces and ensure that they fitted properly into the general ensemble. It is well known that studio helpers often complain after the event that their supposedly crucial contribution to a work has gone unrecognized. Allegations of this kind, to the effect that much of the Rodin's work was in fact done by others, were later put forward by several of his former assistants—for example, by Jacov Nicoladse, a native of Tiflis in Georgia,[7] and by Henri Lebossé, the head of Rodin's studio, who specialized in making enlargements from plaster casts. Of course, all these people had a hand in producing the monument, but the ideas and formal inspiration originated elsewhere. Our knowledge of Camille's work with Rodin is mainly derived from the account that she herself gave to the art critic Mathias Morhardt after the definitive breakup of the couple's relationship in the spring of 1898. Inevitably, her memories were subjective: her respect for Rodin was vitiated by feelings of disappointment, bitterness, and sheer hatred, which scarcely made for factual accuracy. This means that her comments need to be treated with extreme caution instead of being taken—in the manner of many commentators—as gospel truth. In the numerous paeans of praise to Claudel and her art, she has repeatedly been assigned the role of an advisor and mentor to Rodin. The time has surely come for a more sober appraisal of her contribution, which in some cases has been represented as more important than his.[8]

First, however, let us examine the subsequent development of Camille Claudel's own work. We have already mentioned the second portrait bust of her brother, in the pose of a young Roman, which she completed in 1884. The motif is interesting for several reasons. Here we find Paul Claudel, at the tender age of sixteen, already adopting the stoical attitude that was to characterize his later life and work. The neoclassical tenor of his thinking is clearly apparent, although the religious spark that lit up his poetry from the turn of the century onwards has not yet been ignited. Yet Paul already exhibits the imperious self-esteem that his elder sister gladly endorsed until she, too, began to suffer under its oppressive effects. The thematic content of the bust is echoed by its almost classical form, reflecting the approach which was still being pursued by the French academic tradition, albeit with the admixture of elements taken from the neo-Renaissance style of the so-called Florentine group of sculptors headed by Paul Dubois. It was with this "Roman" bust of her brother and the head of *La Vieille Hélène*—two stylistically quite different works—that Camille Claudel first placed her art before the wider public. When submitting the works for exhibition, and in the catalogue notes, she was required to follow the usual custom of naming her teachers. At her debut in the 1883 Salon, with the bust (apparently lost) of a certain Madame B., she had already claimed to be a pupil of

Dubois and Rodin. Yet she had received no formal instruction from Dubois, who had been, at most, an advisor; and Rodin had only been teaching her for a short while. Neither in *La Vieille Hélène* nor in the bust of her brother is the impact of Rodin's thinking apparent. The former work is too dryly naturalistic and the latter too conventionally neoclassical. However, the spirit of Rodin's sculpture is perfectly captured in a fourth work, titled *Giganti*—a wonderful man's head cast in bronze, with fluttering locks and a bold, determined expression. In 1885 Camille exhibited this work at the Salon. It was bought by Baron Alphonse de Rothschild and later donated to the Musée des Beaux-Arts Thomas Henry in Cherbourg. This indicates that, from 1885 onwards, Camille Claudel's art closely followed the pattern set out by her teacher.

It is safe to assume that Camille found her involvement in *The Burghers of Calais* project in 1885-86 tremendously instructive. The heads of the citizens, conveying a mixture of suffering and defiance, determination and despair, self-sacrificial heroism and terror at the prospect of imminent death, were far superior to anything produced by Rodin's predecessors in the field of monumental group sculpture. Camille's *Giganti* is undoubtedly a fine kindred achievement, but it stands in the context of Rodin's work on the citizens' faces, which Camille appears to have studied closely, making sketches of her own as the work progressed.

A further pointer to the close connection between *Giganti* and Rodin's work is furnished by a preliminary plaster study that was discovered after Claudel's death and shown for the first time in the 1951 memorial exhibition at the Musée Rodin in Paris. Rodin used this as a model for the head of Avarice in *Avarice and Lust*, a depiction of two of the deadly sins that also appears in *The Gates of Hell*, where the figures are inverted and incorporated into the bottom left corner of the right-hand door. In this particular case, Rodin evidently accepted and used the study made by his assistant. With his permission, and under his watchful eye, Camille made a further version of the head after the Neapolitan model who was posing for Rodin at the time and supplied the figure for *Ugolino* and several other works. This second version of the head resulted in *Giganti*. At least four bronze casts of the head were made. The cast exhibited in Paris in 1885 is probably the one bought by Baron Alphonse de Rothschild and presented to the Musée des Beaux-Arts in Cherbourg; it is signed twice with the name "Camille Claudel." A second, unsigned version is owned by the city museum in Lille. The third cast was bought by the dealer H. Fontaine some time before 1913. In the collection of the Kunsthalle Bremen there is also a cast—with a shorter neck—which bears Rodin's signature and was bought by the museum in 1960 as an example of Rodin's work. This "fake" was probably not

Camille Claudel,
Giganti, 1885

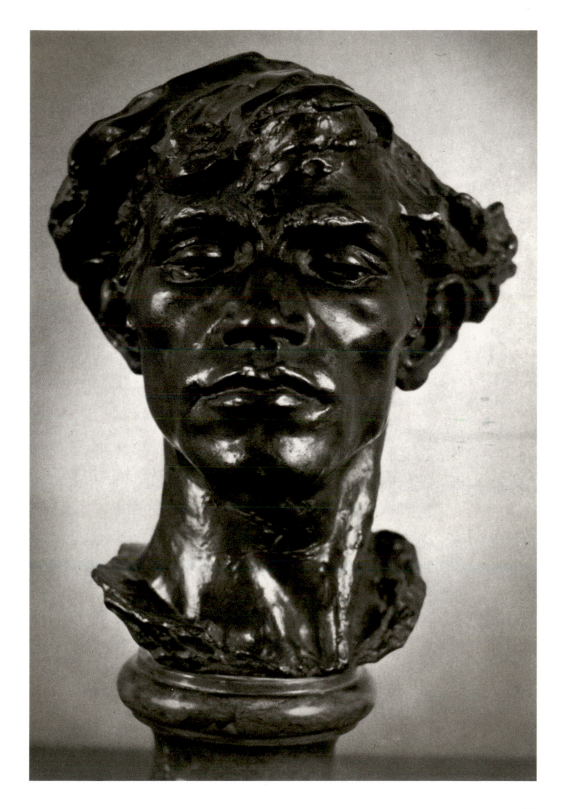

Camille Claudel, *Study for Avarice and Lust*, ca. 1883

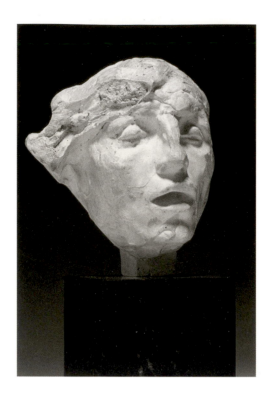

Rodin's doing but was produced by an enterprising art dealer or foundry owner who took the plaster cast from her estate, or from her faithful caster Eugène Blot, or from some other person, and then removed the part of the neck bearing her signature, forged Rodin's name on the remaining section, and recast the work in order to pass it off as a "genuine" Rodin which would command a higher price.[9] The strikingly accentuated mass of hair in *Giganti*, parts of which are given a more nuanced structure, reflects Camille Claudel's penchant for modeling details of coiffure, as seen in a number of her heads of women and children, and especially in the figure of *Clotho*. Rodin was less interested in this particular feature.

It was probably in this same year that Rodin made his second portrait of Camille Claudel. The work was intended to be a marble sculpture but was only executed in that material many years later. Based on an extended metaphor, it shows her face emerging from a cloud of stone, like the morning sun breaking through the night sky: hence the title, *L'Aurore*. Rodin may have been thinking of the sculptures made by Michelangelo for the

Medici Chapel in Florence, especially of the figure representing *Day*, which was deliberately left in a semi-rough state in order to symbolize the gradualness with which darkness gives way to light. At all events, *L'Aurore* is one of the first completed sculptures in Rodin's oeuvre to receive the *non finito* treatment, using the unfinished look as a calculated artistic device with a specific symbolic meaning.

The choice of Camille's face for the head emerging from the cloud of marble is anything but coincidental. It was a face that continued to fascinate Rodin, and it signified a dawning of a very real kind, in the sense that his life was entering a new phase.

Auguste Rodin, *Avarice and Lust*, 1880-83

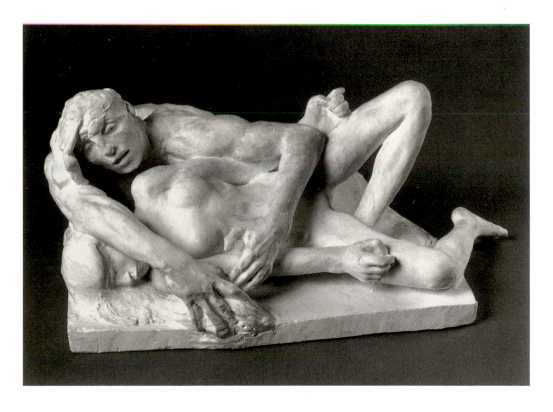

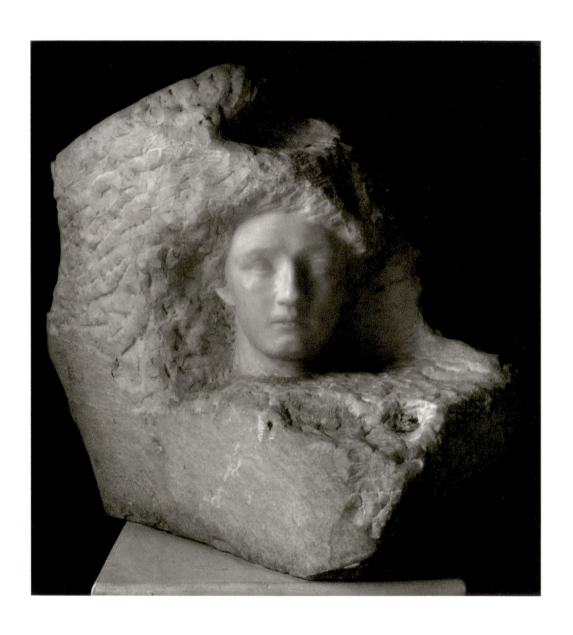

Auguste Rodin, *L'Aurore*, 1885 (?)

The Eternal Triangle:
Rodin, Camille Claudel, and Rose Beuret

Since 1864-65 Rodin had been involved in a long-standing relationship with Rose Beuret. The attractive seamstress, who originally hailed from the eastern part of the Champagne region, had remained loyal through thick and thin, even in the most direly straitened circumstances. As well as posing for Rodin in her youth, she acted as his housekeeper and studio assistant and took in sewing to help pay the bills. Moreover, she was the mother of his son, Auguste Beuret—in his father's eyes, a disappointing failure. Rose had been Rodin's companion and confidante during the most difficult period of his life. She had then accompanied him to Brussels, where the couple were later said to have spent their happiest years together, following Rodin's success in finding employment that paid enough to guarantee a reasonable standard of living. From the end of the 1870s onward, after Rodin's return to Paris, the household steadily grew, and new assistants were recruited to help in the studio. Rose realized that an artist of Rodin's dynamic temperament could not be faithful in the conventional sense; after all, his main interest as a sculptor lay in the female body, and he continually needed new models as fresh sources of inspiration. Although she occasionally grumbled and later staged occasional open protests, she generally accepted his refusal even to consider the idea of marriage. It was only in 1917, the year of their deaths, that she and Rodin finally tied the marital knot. Yet Rodin knew that he could always rely on Rose, and despite everything else that happened he remained loyal to her in his own way. Over the years, even after the end of his relationship with Camille Claudel, he had a number of extramural affairs which Rose quietly tolerated—in so far as she knew, or suspected, that they were going on—as long as they did not seriously jeopardize her position as the artist's "senior" mistress and detract from the respect accorded to her by outsiders, who thought of her as "Madame Rodin." She knew that she could not tie Rodin down. It had long been his habit to travel alone, rarely taking her with him. The larger the household became, the more time Rose was obliged to spend at home, looking after her illegitimate son, who was incapable of doing anything for himself, and supervising the staff, whose number grew considerably from about 1885 onward. She assumed responsibility for the domestic side of her and Rodin's life, ensuring that the household was properly run.

The intellectual and artistic circles of Paris knew of the relationship between Rodin and Rose Beuret, and Camille Claudel must have been aware

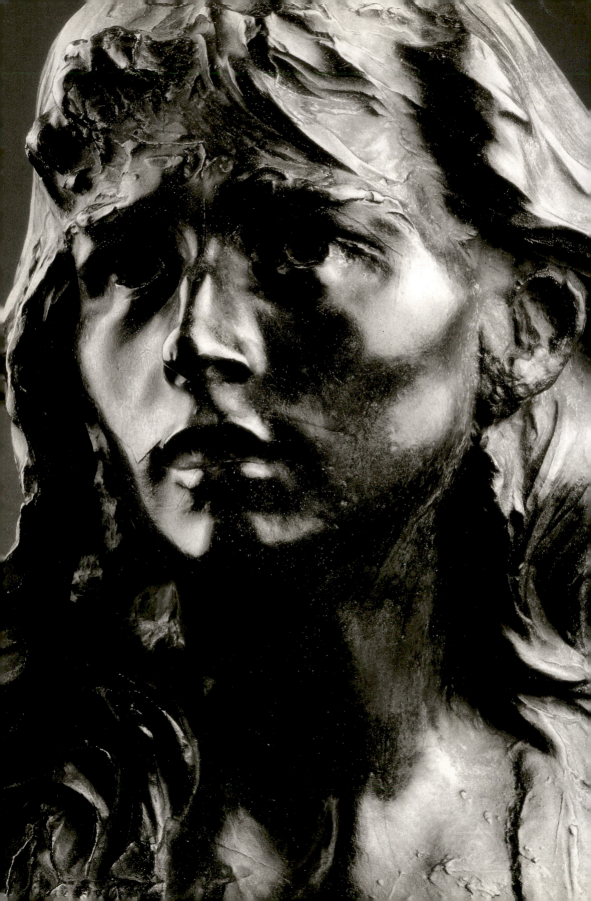

of it, too, at least from the point in 1885 when she and her English friend Jessie Lipscomb went to work in the master's studio. At first—and possibly later, as well—she may have seen Rose as an older woman who was no match for her own youth and beauty. At forty-one, Rose was fully twenty years older than Camille and only four years younger than Rodin himself. Living a quiet, secluded life, Rose appeared to be cast in the role of a domestic servant rather than a mistress. She had no real interest in intellectual or artistic matters and was incapable of conducting a conversation on anything like the same level of aesthetic argument as Rodin's friends from the art world, the Academy or the university. With his literary bent and philosophical ambitions, Rodin had acquired a circle of professional acquaintances in which Rose was essentially an outsider. This doubtless raised Camille's hopes of edging her rival still further into the background as her own relationship with Rodin grew ever closer. In the years that followed both Camille and Rodin must have experienced periods of intense, tempestuous excitement, not only with regard to their artistic collaboration but also in terms of erotic experience. The year 1886 probably marked the first of these climactic phases, although it also cast a number of early shadows over their relationship, which was conducted more or less in secret.

A Private Marriage Contract

One of the most remarkable extant documents from this period, when the couple's involvement was at its height but was simultaneously endangered by the vacillation of both partners, is the promissory letter drafted by Rodin on October 12, 1886, that was found only recently—in 1989—among the papers in his estate.[10]

Here, as if entering into a legally binding agreement, Rodin solemnly declares that Camille shall henceforth be his sole and only pupil, and that he will support her "by every means," including the use of his influence to ensure that her work is prominently displayed in exhibitions and favorably reviewed in the press. He also promises that until May 1887—the date of the annual Salon—he will eschew all involvement with other women and specifically states that any infringement of this provision "shall render this agreement null and void." After the exhibition in May, which both partners were evidently working towards, Rodin and Camille are to travel together to

Auguste Rodin,
Mignon (Rose Beuret),
ca. 1869

Italy and stay there for at least six months as a preliminary to "a permanent relationship or liaison, to the effect that Mademoiselle Camille shall be my wife." Thus the letter amounts to a promise of marriage, backed by a pledge to abandon all other women.

The remaining provisions are of secondary importance, except in so far as they indicate that the contract as a whole was dreamed up by Camille and dictated, as it were, to Rodin. Typically, for example, she demands to be photographed in her best dress (which she had worn at an Academy reception) by the celebrated Paris photographer Carjat, who produced one of the most inspired camera portraits of Baudelaire. She also reserves the option of having a second photograph taken in one of her evening dresses. Rodin has to promise, furthermore, that he will take her to Chile, instead of Italy, if he is awarded the commission to design the projected equestrian statue of General Lynch in Santiago. (This means that Rodin's eighteen-inch-high maquette for the statue, now in the Musée Rodin, had already been made by the fall of 1886. A subsequent revolution in Chile put an end to the plans for the monument, and the expected trip consequently fell through.) In "recognition" of these various undertakings, Camille agrees to receive the master at her studio four times a month until the following May. The document reads like a marriage contract—or a formal agreement concerning the rights and duties of a mistress—between persons of the highest social standing. Unfortunately, it would seem that the promised full-dress photographs were never taken, otherwise we would no doubt have a more impressive picture of the twenty-two-year-old sculptor than the one that Carjat took of her in an ordinary striped costume.

Most of the other pledges were not redeemed or were only fulfilled in part. Neither did the six-month stay in Italy take place, nor did Rodin make good his promise of marriage. With her exceptionally mercurial temperament, Camille was continually torn between the very strong affection she felt for Rodin and her defiant urge to avoid being swallowed up by a relationship that stirred up deep-seated inner fears. This, together with her awareness of the problems faced by others in similar situations, continually led her to hesitate and draw back. The erotic and creative drama played out at fever pitch between the couple was later compared with the tragedy suffered by the painter Pierre-Paul Prud'hon (1758-1823), the creator of the Romantic portrait of the Empress Joséphine that now hangs in the Louvre. Prud'hon was married but fell in love with one of his pupils, a certain Mademoiselle Mayer, who resorted to suicide as the only possible avenue of escape from an entanglement that flew in the face of propriety.

The 1886 Salon did not feature any particularly outstanding works by Camille: her only contribution was a terracotta bust, made the previous

Camille Claudel, 1886. Photograph by Etienne Carjat

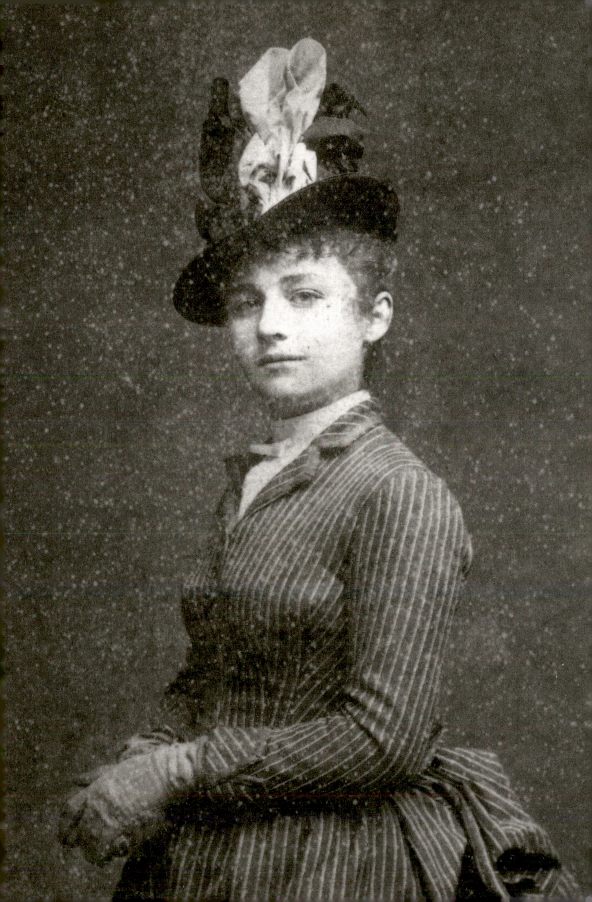

year, of her sister Louise. With its delicately curled hair and boldly animated gaze, the figure calls to mind the Rococo-style portraits of girls and young ladies that enjoyed a considerable vogue between about 1860 and 1875. In his early years, Rodin paid forced tribute to the same style, and even much later, he made occasional use of it, as one of the many possibilities in his varied personal repertoire. However, he saw it as essentially unimportant; to him, it represented no more than a reminiscence of the eighteenth century.

Emotional Vicissitudes

Camille Claudel's bust of Louise may well have been a conscious exercise, exploiting the opportunity to use a model from her own immediate family in order to acquire practice in imitating the styles of the past. She was thus following the example of Rodin himself, whose ideas and technique had evolved, in characteristic nineteenth-century fashion, by studying the various stages in the historical development of sculpture. It is interesting to note that in his review of the Salon exhibition, the critic Paul Leroi praised Camille's work in general terms but added a note of warning: "It is essential that the young artist be Mademoiselle Claudel herself, and not a mere reflection."[11] This was an obvious allusion to her lack of originality, as a sculptor who was enslaved either to the past or, more importantly, to Rodin, her teacher. The criticism must have struck home and set her thinking. But for the time being, she was largely preoccupied with the work she was doing for, and with, Rodin. In 1886, the master made his third portrait of Camille, the famous head known as *The Thought*, which was later executed in marble and is regarded as one of his most poetic symbolist sculptures of young women. Together with the plaster fragments in the Rodin estate in Paris, the preliminary study in terracotta owned by the Museum der Bildenden Künste, Leipzig, shows that the artist's handling of the subject was based on very careful preparations. It is impossible to imagine that Rodin modeled the head spontaneously and then decided to endow it with a further meaning by mounting it on the block of marble from which it emerges.[12] On the contrary, it must be assumed that he had been thinking for some time about creating a work that would symbolically encapsulate Camille's occasional fits of melancholy and her continual fruitless brooding over her vocation, her creativity, her relationship to her teacher—over life in general and the transience of mortal things. These musings took place

Auguste Rodin,
The Thought, 1896.
Detail

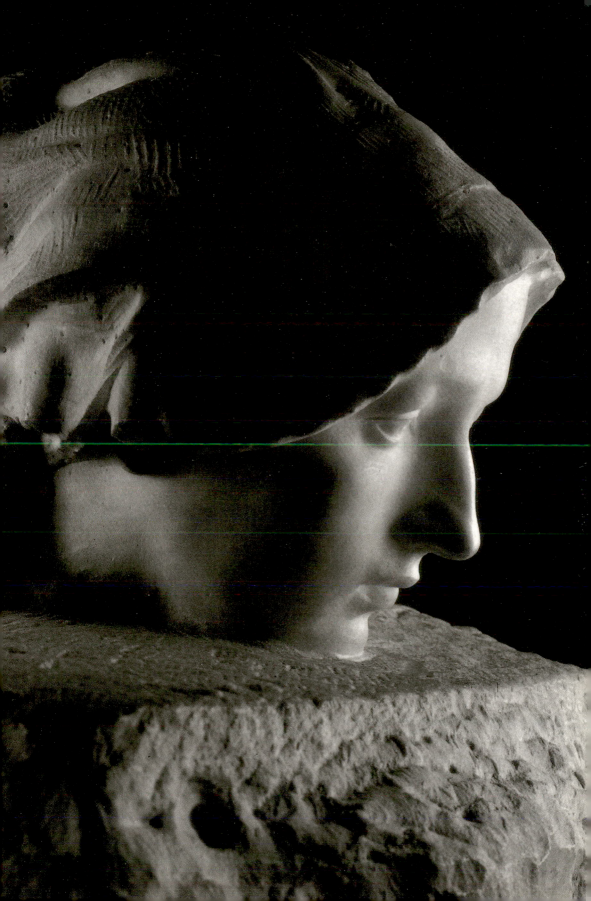

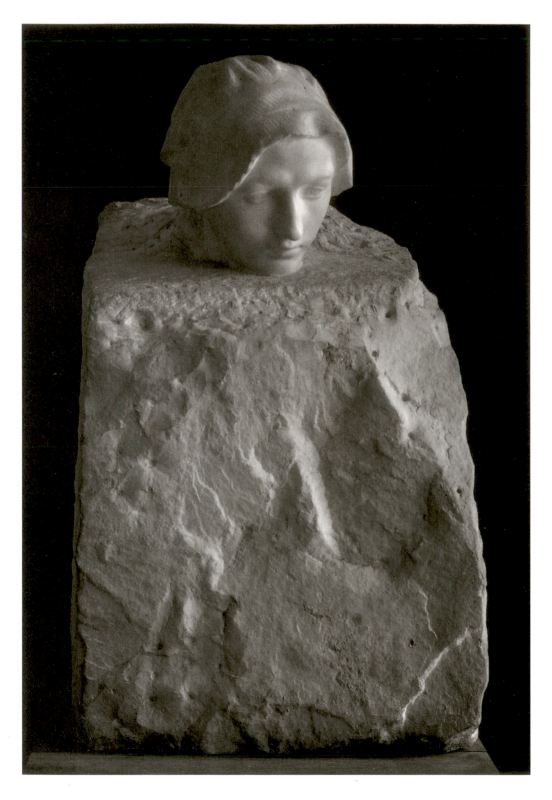

in the shadow of *The Gates of Hell*, in which the bodies of the striving figures, racked by yearning and suffering, are ultimately condemned to plunge back into the void. Seen in this context, *The Thought* takes on the status of a biographical document relating to artist and model alike; but at the same time, it also makes a general human statement about the sense of being pinned down by the shackles of earthly existence, from which our thoughts and visions offer only a temporary, fleeting escape. The problem is very similar to that addressed in the statue of *The Thinker* that Rodin made for *The Gates of Hell*. Here, the figure pondering over the meaning of life is unable to free himself from the tangled skein of his own thoughts. These are wonderful dramatizations of the philosophy of life that Rodin pieced together for himself on a largely intuitive basis, with little knowledge of the relevant writings.[13]

The Thought contains a further significant aspect. The portrait of Rodin's beloved pupil and muse, the headstrong, wayward young woman who alternately accepted and rejected his advances, prophetically anticipates the fate that was to befall her: the disintegration of her personality and the schizoid dissociation of thought and feeling that locked her in a prison whose walls were as solid as the marble that was her preferred material for sculpture. Her head is almost submerged in the massive block of stone. (The scholar Grunfeld suggests that the partial burying of the neck was a deliberate ploy by Rodin to disguise Camille's weak chin. This would appear to be a somewhat superficial interpretation, which fails to take the deeper psychological issues into account and ignores the fact that Rodin made no attempt to hide the chin in his other portraits of Camille.)

Whatever meanings one may choose to read into this remarkable example of marble sculpture, it still remains a highly enigmatic work.[14] The strange cap worn by Camille has been identified as a Breton nuptial head-dress or young girl's bonnet. Since it also appears in the preliminary study in Leipzig and the plaster fragments in Paris, it must have been designed at an early stage, which implies that Rodin attached considerable importance to it. In formal terms, it has a defining function, establishing a clear dividing line between the head and the space above, in response to the solid, coherent mass of the block on which it stands. The latter, it should be said, is not a plinth of the usual kind but an integral part of the figure. Beneath its surface, one senses the invisible outlines of the subject's body, or at least of the chest and shoulders that feature in normal portrait busts. *The Thought* also conveys the ambivalence of Rodin's feelings toward Camille, whose character he found eternally puzzling. Unfortunately we have no record of her reaction to the work, the completed marble version of which was only exhibited some ten years later, at the 1895 Salon.

Auguste Rodin,
The Thought, 1896

One might consider whether the sculpture was a product of the mood that befell Rodin and put him temporarily in a state of paralysis after Camille's escape to England in the summer of 1886. Both partners must have worried a great deal about the physical aspect of their relationship; and, moreover, there is the matter of the two illegitimate pregnancies alluded to in Jessie Lipscomb's recollections, although we do not know the dates at which they may have occurred.[15]

The year 1887 probably saw further tensions that tested the relationship almost to the breaking point. It would seem that the formal "contract" drawn up in 1886 was put away in a drawer and forgotten. Having completed the life-size figures of the burghers of Calais, which were later cast in bronze, Rodin addressed himself with renewed vigor to *The Gates of Hell*. With the latter work in mind, he made a number of new groups which—like *Eternal Springtime*, the first version of which, judging from the inscription on one of the casts, dates back to 1884—were also conceived as separate sculptures in their own right. Again and again he returned to the themes of desire and despair, of unrequited love and hopeless yearning. In this area, his stock of ideas appears inexhaustible. He made several sculptures based on the motif of Paolo Malatesta and Francesca da Rimini, the tragic adulterous couple to whom Dante assigned the grim punishment of riding forever on the whirlwind, eternally together but never united. The best-known treatment of this theme is *Fugit Amor*. Further versions fol-

Auguste Rodin,
The Devil – Milton
(not dated)

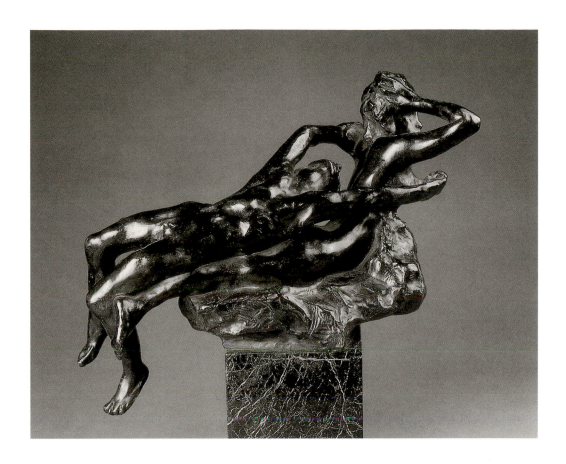

Auguste Rodin, *Fugit Amor*, before 1887

lowed, some of which found their way into *The Gates of Hell*. Moreover, Rodin sculpted an endless series of anguished couples, locked in a passionate embrace yet drifting inexorably apart, exhausted by struggle. This exactly paralleled the atmosphere in the studio where Camille, alongside others, was working with Rodin and trying at the same time to create something that would be entirely of her own making. The few of her nude studies that have been preserved—*Crouching Man*, a woman's torso, a hand and several heads—emphasize the proximity of her style to that of Rodin. *Crouching Man* is a variation on Michelangelo's sculpture of the same title and on Rodin's *The Crouching Woman*. However, these works also demonstrate Camille's grasp of anatomy and her talent for modeling the play of muscles and the soft swellings of human flesh—an area in which Rodin was the acknowledged master of his day.

In the spring of 1887, before going back to Paris with an English artist-friend to rejoin Rodin's studio, Jessie Lipscomb wrote a letter to the master

43

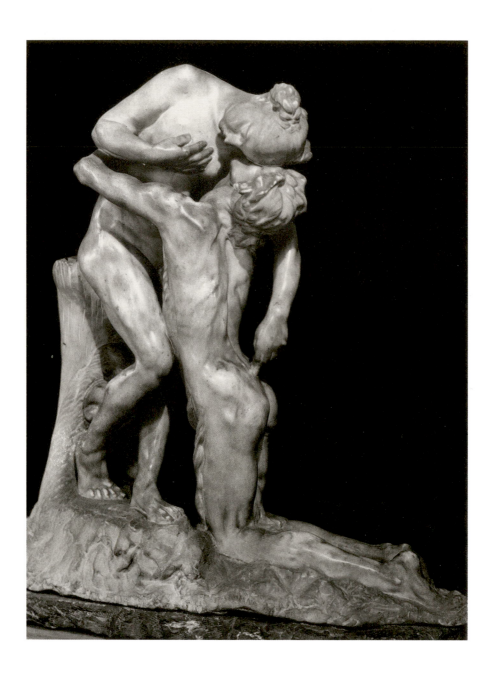

Camille Claudel, *Sakuntala*, 1905

Auguste Rodin, *The Eternal Idol*, 1889

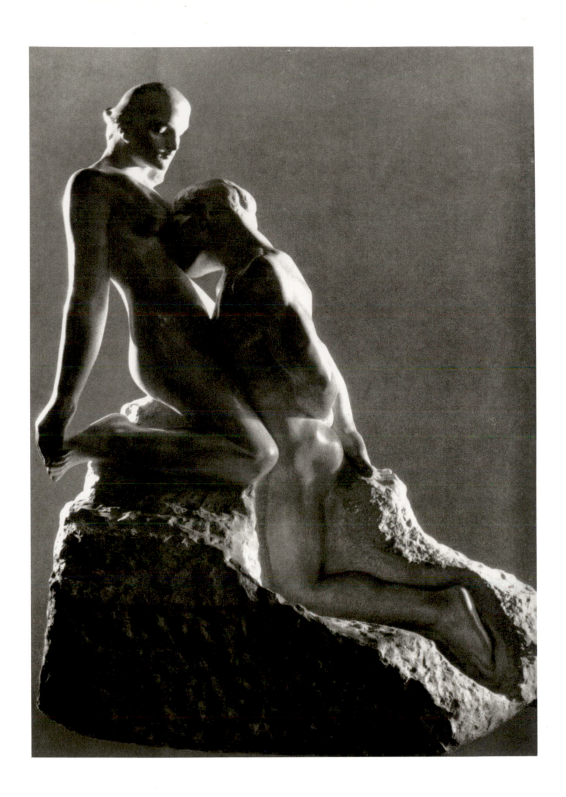

that gives us an idea of the ruffled atmosphere that resulted from his relationship with Camille. In a telling comment, she declared: "We won't stay with Mlle Camille if that upsets you, and your differences with her are no concern of ours."[16] One can well imagine the difficulties caused by the combination of Camille's moody behavior with the outbursts of raging temper to which she, and Rodin, were increasingly subject. Working in the same room, they fought until the fur flew. The incessant arguments must also have worn on the nerves of the protagonists in this drama.

At this point Camille, too, sculpted a pair of lovers, which she titled *Sakuntala*, after the Indian legend set down in dramatic form by the fifth-century Sanskrit poet Kalidasa. Although the subject appears remote from today's concerns, the drama was much esteemed by the Romantics of the nineteenth century and translated into all the major European languages. Anyone versed in literature would therefore have been familiar with the theme. While out hunting, Prince Dushyanta stumbles upon the maiden Sakuntala, the offspring of a saint and a nymph, who has been adopted by a hermit. Dushyanta falls in love with the girl, and they are united according to an ancient rite; he then departs, leaving Sakuntala his ring as a pledge, and returns to his castle. For the time being, Sakuntala continues to live with the hermit, who one day receives a visit from Durvasas, a sage. Sakuntala is so preoccupied with thoughts of her lover that she fails to show Durvasas the reverence which is his due. The old man avenges himself by casting a spell on the Prince so that he will forget Sakuntala and only recover his memory of her on seeing the ring. Calamity soon strikes. On the advice of her adoptive father, Sakuntala goes to the palace, but the Prince fails to recognize her; having lost the ring that morning, she is unable to show it to him. After retreating into the depths of the forest, she gives birth to a baby boy, who was conceived on the night of her wedding. One day, a fisherman finds the ring in the belly of a fish he has caught. He brings it to the Prince, who promptly awakes from the spell and remembers his love for Sakuntala. Ridden with guilt, he goes off to search for her. Eventually he finds her in the forest, acknowledges the child as his own son, and escorts Sakuntala back to the palace as his queen.

Camille Claudel's sculpture captures this dramatic moment of recognition, as the Prince kneels before Sakuntala, ruing his forgetfulness and renewing his pledge of love. Sakuntala is gradually sinking into his embrace; her left arm is limply outstretched toward him, while her right hand protectively covers her breast. The Prince shyly and tenderly enfolds her in his arms, scarcely daring to touch her body.

It should be remembered that Rodin, too, made numerous sculptures featuring pairs of lovers, notably from 1880 onward in conjunction with

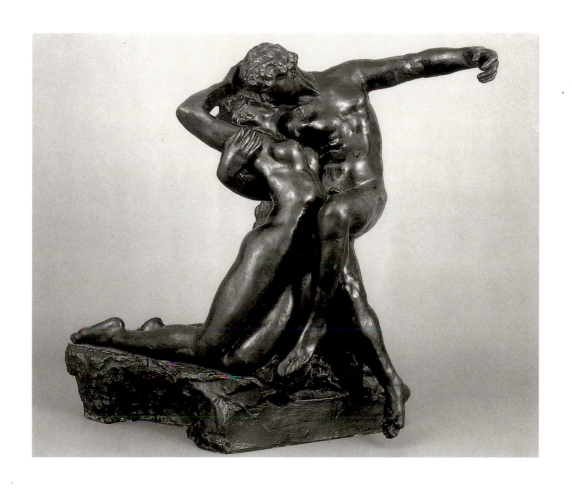

Auguste Rodin, *Eternal Springtime*, 1884

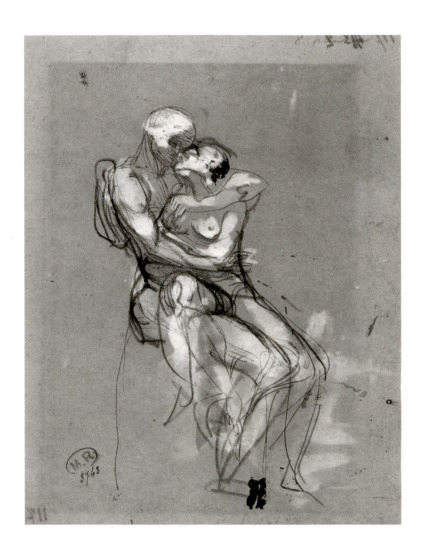

Auguste Rodin, *Paolo and Francesca da Rimini*, ca. 1880

Auguste Rodin, *The Kiss*, 1888-98

48

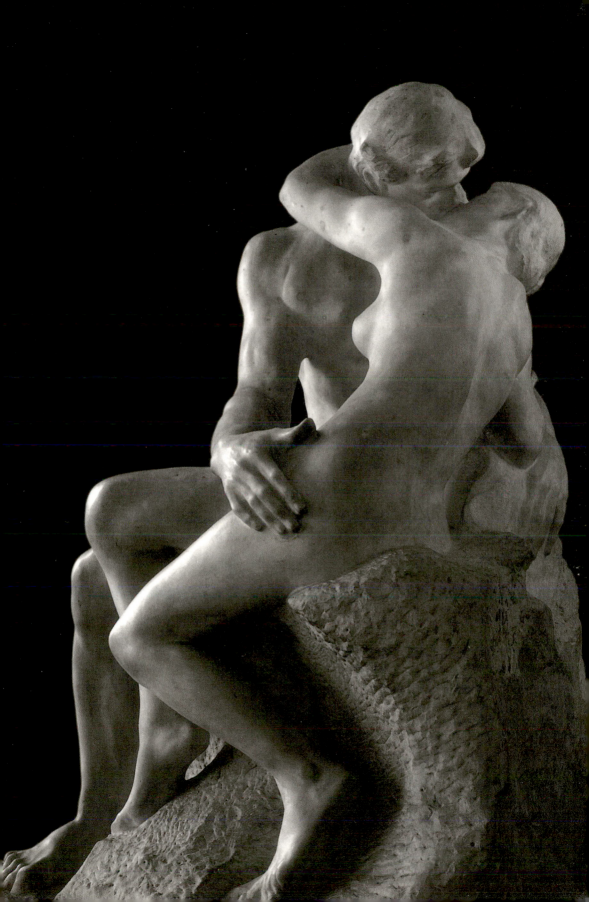

The Gates of Hell. The first version of *Sakuntala*, dating from 1888 (executed in marble in 1905), was preceded, for example, by Rodin's *Eternal Springtime*, made between 1881 and 1884 and cast in bronze in 1887. The respective roles of the two figures are reversed, however. In Rodin's sculpture, the woman is shown kneeling in front of the seated young man, who leans toward her and throws his right arm around her body as the couple's lips meet in a kiss. Rodin's figures have a more animated, almost dance-like quality. The work's original title was *Zephyr and Earth*, which explains the rudimentary wings—not visible in most photographs of the sculpture—on the male figure's back. Hence also the sense of movement, as if the youth, representing the god of the mild southerly wind, had briefly descended from the air to embrace and kiss the earth, symbolized by a young woman kneeling on the ground. The work was later given the title *Eternal Springtime*, which has less of a mythological ring.

An even more famous rendering of the theme of the embracing couple is found in Rodin's *The Kiss*, which dates back to the period around 1880, when the sculptor was doing the first preliminary studies for *The Gates of Hell*. *The Kiss* was originally conceived as an "illustration" of the story of Paolo Malatesta and his sister-in-law Francesca da Rimini in Dante's *Divine Comedy*. In Dante's version of the tale, the ill-fated lovers were tempted into adultery by reading the romance of Lancelot and Guinevere, the book lying on the stone seat behind the woman's back. She eagerly throws her arm around her lover's neck, drawing him toward her and exacting a kiss from him. One of her legs is resting on his thigh—a common symbol of sexual union in mannerist art.

Compared with this work, Camille's *Sakuntala* (also known as *Surrender*) is relatively restrained. There is a certain decorous awkwardness to the figures, and they display no signs of aggressiveness. Paul Claudel praised the work for this very reason, contrasting it with what he described as the "crude sensuality" of *The Kiss*. However, his glowing tribute to his sister cannot be taken entirely at face value. Grunfeld, for example, describes Paul's prose as "magnificent and fatuous," emphasizing that it reveals more about Paul Claudel himself than about the idealized figure of Camille, who, unlike her brother, made little attempt to conceal the sensual side of her nature.[17]

Nevertheless, it has to be acknowledged that *Sakuntala* contains a biographical element. In using the Indian legend, Camille was alluding to Rodin's failure to redeem his promise of marriage and to her own hopes that he would return, full of remorse and longing, to "recognize" her once again—the woman, who, alone and deprived of his protection, bore his child. But here, we find ourselves in a maze of unanswered questions.

It is entirely possible that *Sakuntala* provided Rodin with the inspiration for *The Eternal Idol* (1889), which bears a strong superficial resemblance to Camille's sculpture. Rodin's work is bolder, however, being at once more sensual and more solemnly reverent. Again, the young woman sits in a raised position with the man kneeling before her; but in this case, his hands are clasped behind his back, as if he were handcuffed. Unlike the Prince in *Sakuntala*, he does not even attempt to embrace the woman he loves, yet the position of his body indicates that he feels very close to her, and his head is bent forward to place a kiss under her breast. With closed eyes and an expression of surrender, the woman is simply allowing all this to happen. But although she is not an active participant, her pose clearly signifies acceptance rather than rejection. Arching her back, she is offering her body up to her lover's caressing lips, and she seems to expect and hope that his shy, yet fervent gesture of adoration will eventually lead to complete physical and spiritual union. The contrast between the male and female poses is further heightened by the playful gesture of the woman's right hand, which is exploring the sole of her right foot. In formal terms, this gesture serves to complete the triangle described by the female figure. The sense of erotic tension is far stronger than in *Sakuntala*, and this aspect of the work has made it one of Rodin's most celebrated "amorous" motifs. *The Eternal Idol* is an invocation of *das ewig Weibliche*, the Eternal Feminine, from a specifically male point of view. Here, Rodin glorifies Woman with an almost religious fervor, and it is far from coincidental that the work was also known as *The Host*, an alternative title which the sculptor's contemporaries evidently did not feel to be blasphemous—with the possible exception of Paul Claudel, who always imputed the basest of motives to Rodin and accused him of "wallowing in erotic filth." Apart from this aspect, the female figure in the sculpture also has a certain sphinx-like quality. To the man kneeling before her, she seems as mysterious and enigmatic as Camille was to Rodin. On seeing this work, Camille must have recognized the symbolic allusions to the relationship with her teacher; and at the same time she must have realized that she herself was incapable of achieving such a complex and multilayered evocation of erotic passion.

During this phase of the relationship between Camille and Rodin there must also have been occasional periods of mutual understanding and great happiness. This is demonstrated, for example, by the *Bust of Auguste Rodin* which Camille made in 1888-89. The sculptor regarded this as the best sculptural portrait ever made of his own features, and it can indeed be called a masterpiece—a masterpiece inspired by the spirit of Rodin's art, and a perfect example of his school. There is some justification for wondering whether the sitter himself had a hand in this portrait by his student

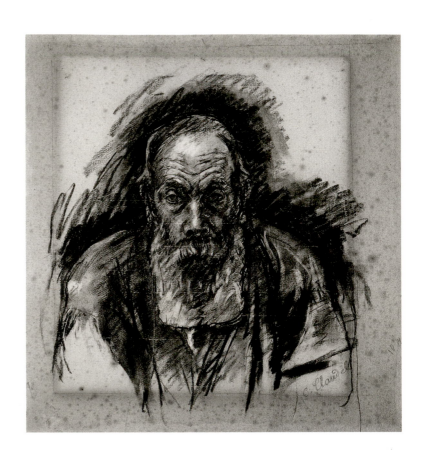

Camille Claudel,
*Portrait of Auguste
Rodin*, 1888

and lover. Certainly, it is her work, but the modeling technique and the feeling for human psychology are so Rodin-like that suspicions are bound to arise regarding his possible involvement in the making of the piece. Moreover, the bust bears a resemblance in kind to the head of Eustache de St. Pierre, the old man in the center of *The Burghers of Calais*.

The bust has of course been seen as an homage to Rodin, and this is often cited as the reason for its stylistic proximity to his work. Comparing it with Rodin's *Self-Portrait*, a charcoal drawing from the 1880s, one particularly notices the gaze. The drawing was evidently done after one of the portrait photographs of Rodin taken by Bergerac in 1886,[18] which also emphasizes the sculptor's habit of screwing up his eyes to compensate for his shortsightedness, and the characteristic creasing of his forehead just above the base of the nose, which lends his expression a sense of energy and dynamism. A very similar expression is to be found in the bust made by Camille Claudel in 1888. In this respect, the bust contrasts sharply with her full-face portrait drawing of Rodin, which was probably done in the

same year, immediately preceding the sculpture. Unlike Rodin's self-portrait, which is drawn with a far greater delicacy of line, Camille's drawing focuses on the plastic quality of the head, stressing the wrinkling of the forehead and bringing out the creases in a way that gives them an almost ornamental appearance and makes the subject appear far older than he actually was. At the same time, the enlargement of the eyes lends the gaze a greater directness and boldness than in Rodin's self-portrait or Bergerac's photograph. This has lent added credence to the supposition that Rodin intervened in the making of the sculpture—acting as an advisor or

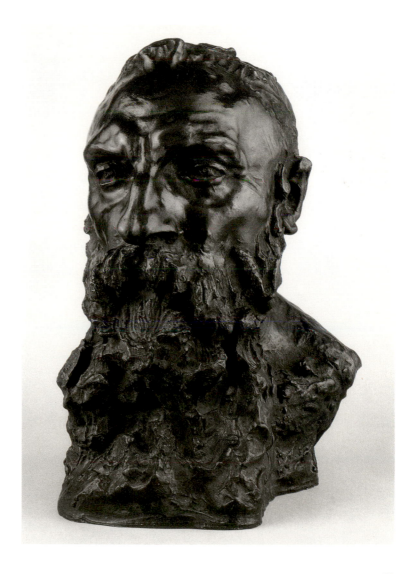

Camille Claudel,
Bust of Auguste Rodin,
1888

possibly even assisting directly in the modeling—and modified this part of the face to make it more realistic. At all events, the bust differs markedly from Camille's drawing; the symmetrical furrows in the forehead have disappeared, and the surface as a whole, including the beard and hair, is more subtly nuanced. In her drawing, Camille sees Rodin in oddly stereotyped terms, as a kind of Old Testament prophet. The bust also endows him with an impressive aura of dignity and concentration, but the face is more life-like and far less stylized than the image in the drawing. Admittedly, Rodin's possible involvement in the work is a matter for pure conjecture, and there is evidence to show that Camille referred to Rodin's self-portrait and the photograph on which it was based while she was doing the preliminary studies for the bust. Nevertheless, one cannot fail to be struck by the Rodinesque quality of the bust's execution. There is an obvious discrepancy between this work and Camille's other portraits, which, with the exception of *Giganti*, tend to be more traditional, with a smoother, more polished look and a greater degree of stylization in the modeling. This is still apparent, for example, in the bust of her brother Paul, aged thirty-seven, which she made in 1905.

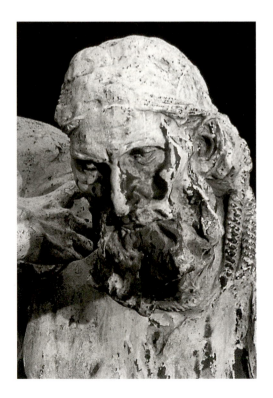

Auguste Rodin, Eustache de St. Pierre. Detail from *The Burghers of Calais*, 1884-86

54

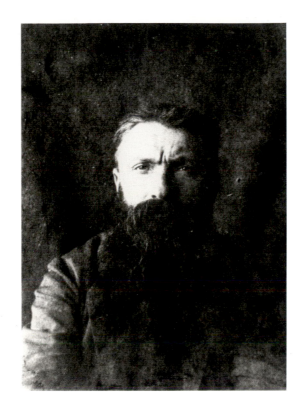

Auguste Rodin,
ca. 1886

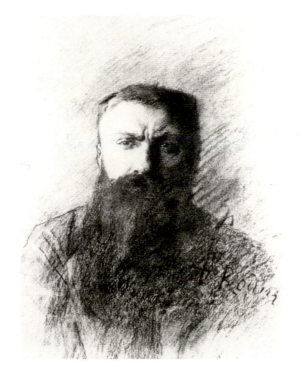

Auguste Rodin,
Self-Portrait,
ca. 1887/88

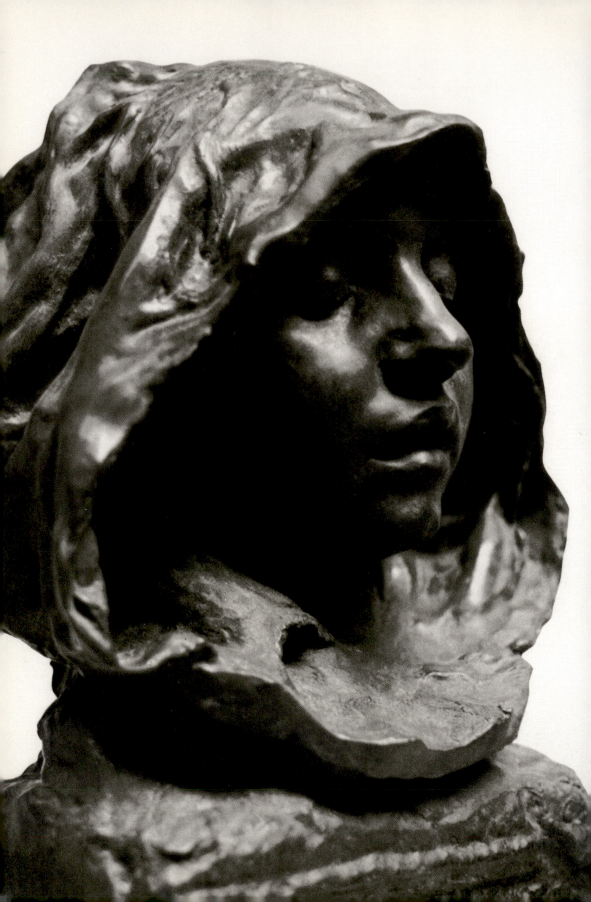

The *Bust of Auguste Rodin* earned Camille much praise when she exhibited it in the 1892 Salon, and the publisher of the newspaper *Mercure de France*—probably at Rodin's instigation—provided the necessary financial backing to cast fifteen copies in bronze. Because of its subject, the sculpture met with a far more enthusiastic reception than any of Camille's previous works. This did nothing to brighten her mood. The press comments of 1887 had heightened her sensitivity to criticism, and she was keen to put as much distance as possible between herself and Rodin. However, her bid for independence was initially unsuccessful. Her next sculpture, a head of a woman at prayer, displayed a greater degree of originality than its predecessors but was ignored by the critics and the public. Known as *The Prayer* or *Psalm*, this work was probably made in 1889. Could it be Camille's answer to Rodin's *The Thought*? Can the imploring gesture be interpreted as having a biographical significance? Under a large hood, which is somewhat reminiscent of the Breton bonnet worn by Camille in Rodin's symbolist sculpture of her, we see the face of a woman wrapped in contemplation. Her closed eyes evoke a mood of deep piety and almost mystical surrender to her religious faith. With its full lips and fleshy nose, the face is not attractive in the conventional sense. Together with the hood, the features indicate that the woman is a peasant rather than a nun. One is reminded of Jules Dalou's *Boulonnaise à l'église* (1876), a sculpture of a seated figure with a hood of very similar cut that falls over her face in much the same way.

Camille Claudel,
The Prayer (Psalm),
1889. Detail

Camille Claudel, *Bust of Charles Lhermitte*, 1889

Auguste Rodin,
*Pain: Remembrance
of Eleonora Duse*,
ca. 1903

Unlike Camille Claudel's portraits of real-life individuals, this work makes deliberate use of a stereotype, its aim being to express the quintessence of a particular emotion. One sees a similar approach in other sculptures of the time, for example, in the busts with titles such as *La Doleur* by, among others, Rodin, Jean Dampt (1853-1946) and Charles-René Saint-Marceaux (1845-1915).

In the same year, Camille made her *Bust of Charles Lhermitte*, featuring the young son of her and Rodin's friend Léon Lhermitte (1844-1925), an artist working in the tradition of Gustave Courbet and Jean-François Millet, who painted scenes of peasant life and religious themes with a rural setting. The bust is one of several portraits of children in which Camille intuitively captured the naivety of the child's mind and the combination of boldness and wonder in its expression. Specifically, it anticipates the various versions of *La petite châtelaine*, the remarkable portrait of a little girl that Camille sculpted in or around 1893. One notes that this interest in the psychology of children has no place in the oeuvre of Rodin.

Attraction and Repulsion

Meanwhile, a number of significant changes had occurred. In 1888, Camille had moved out of her parents' apartment, partly because she was unable to work there, but principally because of the conflicts with her mother, who had withdrawn all support and understanding, roundly condemning her unloved daughter's unseemly liaison with Rodin, whom she considered far too old. Camille rented a small apartment on boulevard d'Italie, while Rodin set up a "secret," unofficial workshop nearby, in an eighteenth-century house known as La Folie-Neufbourg, surrounded by a large garden. The semi-derelict house, which was later demolished, was a romantic setting very much to Rodin's taste. Its previous occupants had included Alfred de Musset and George Sand, and as an oasis of calm set away from the beaten track, it offered an ideal retreat for artistic contemplation and clandestine meetings. In this idyllic atmosphere, Claudel and Rodin lived and worked together for extended periods of relative harmony, despite the inevitable crises that still broke out from time to time. During the summer of 1890 and 1891, the couple spent several weeks in Touraine, a region they had visited briefly in 1887. They found a particularly pleasant place to stay, with an understanding proprietress, at the Château de l'Islette near Azay-le-Rideau. In 1891, Rodin was awarded the commission to design his famous monument to Balzac, and he used the house as a base for his travels around Touraine to study the people of the novelist's homeland.

For Camille, too, the Château de l'Islette was a welcome refuge. At one point, while staying there on her own, she wrote an undated letter to Rodin in Paris, where her eternally busy teacher still had his hands full with several concurrent projects, including *The Gates of Hell*, the *Monument to*

La Folie-Neufbourg,
the eighteenth-century
house rented by Rodin
in 1888

Claude Lorrain in Nancy, the statue of Victor Hugo for the Panthéon, and a second version of the Hugo monument which was never completed. Camille describes the beauty of the castle, and the conservatory where she takes her meals, with its panoramic view of the garden, and informs Rodin of the owner's offer to let the two of them stay there together. She continues: "If you'll be kind and keep your promise [a reference to the "contract"?], we'll be in paradise." She tells Rodin that the river is suitable for nude bathing, but nevertheless asks him to buy her a swimming costume: "deep blue with white piping, in two pieces." In conclusion, she ventures the information: "I go to bed naked to make myself believe you're here, completely naked, but when I wake up it's no longer the same. Kisses, Camille. [PS:] Above all, don't deceive me again with other women!"

Here, Grunfeld comments tartly: "As so often in letters between lovers, the postscript contains the essential message, but that, precisely, was asking too much of Rodin. At this stage of his life he was quite incapable of focusing all his attention on any one woman. In his late forties and early fifties he was more inclined than ever to make up for time lost during the lean years when he had been too poor, and too closely watched, to enjoy other women....The Paris art world had long prided itself on its sexual permissiveness, and Rodin had only to swim with the tide."[19]

Camille gradually found herself forced to realize that Rodin was not going to separate permanently from Rose Beuret. Mathias Morhardt later described how Camille sought to coerce the master into repudiating "his poor old Rose, who had been the companion of his early years, and who had shared his poverty. He could not bring himself to do that, though both as a man and an artist he was passionately in love with Camille Claudel." "She has no sense of fair play," Rodin once remarked, "just like all women."[20]

Such a verdict, coming from Rodin of all people, can only be understood by reference to the prevailing double standard which allowed men every possible freedom but imposed severe moral restrictions on the behavior of women. Camille, however, was perfectly prepared to take issue with this attitude. Let us leave aside the unsubstantiated rumors of raging disputes, to the point of exchanging blows, between Camille and Rose. Even without such excesses, the ménage à trois was a nerve-racking business for all concerned. At the beginning of the 1890s, Rodin's fame was approaching its zenith—he was already known as the Michelangelo of his day—and the higher his star rose, the more difficult his domestic situation became. Camille fell into a state of apathy and began to avoid Rodin's company, retreating into her shell but not going so far as to break off the relationship once and for all. In 1892, however, she moved out of the couple's shared

Auguste Rodin,
The Farewell, 1892

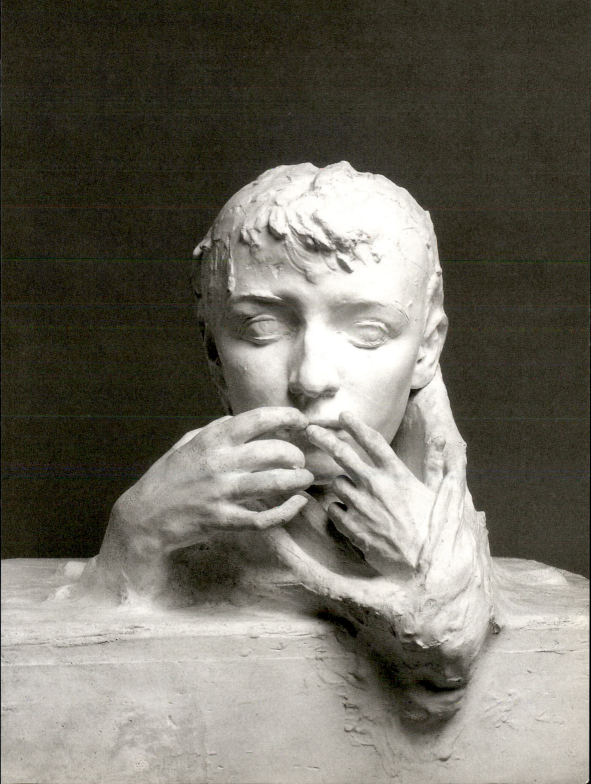

Auguste Rodin, *The Convalescent*, 1892 (?)

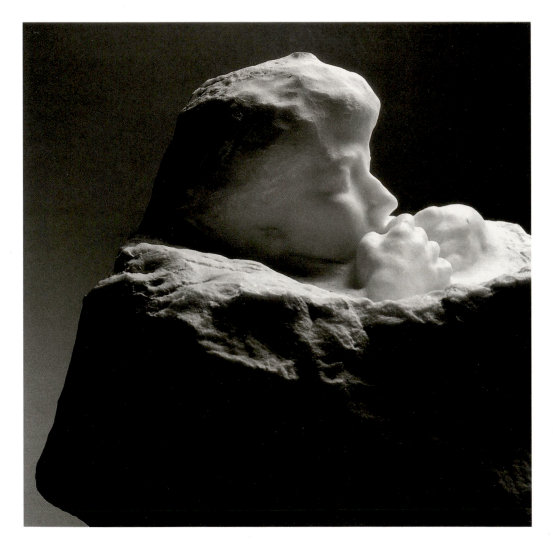

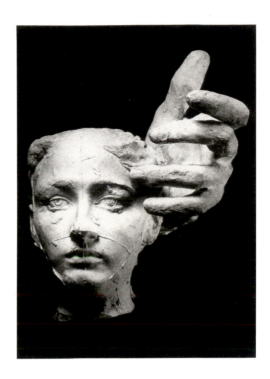

Auguste Rodin, *Assemblage of the Head of Camille Claudel and Left Hand of Pierre de Wiessant*, ca. 1892

studio. At the time, Rodin was modeling his fifth and sixth portraits of her, titled *The Convalescent* and *The Farewell*. Although they are quite distinct from one another, both sculptures show an imploring, weeping Camille clapping her hands over her mouth—hence the alternative title *Silence*. Despite the implicitly optimistic title of the first version, which suggests that the figure has been ill but is now on the road to recovery, the dominant impression is one of pathological melancholy and despair. Rodin probably did not sculpt the portrait from scratch but simply took the well-known plaster head of Camille which he had made several years before, modified the position and formal setting, and added the hands. In *The Farewell*, the hand gesture can be interpreted in two alternative ways: not only as enjoining an imaginary interlocutor to be silent, but also as blowing a kiss. But in *The Convalescent*, the emphasis is firmly on suffering and tears. There is also a third portrait study of Camille Claudel from this period (bringing the total up to seven), which may well have been executed after *The Convalescent* and *The Farewell*, and was shown for the first time in the major exhibition "Le Corps en morceaux," held in 1990 at the Musée d'Orsay in Paris and the Schirn-Kunsthalle in Frankfurt. In the catalogue, Anne Pingeot describes this work as a plaster cast from the earlier head of Camille, which Rodin combined with a hand taken from one of the figures in

The Burghers of Calais, namely, the young man conventionally referred to as Pierre de Wiessant. The hand, whose size is disproportionately larger than that of the head, extends from the back of the skull to the front, with the palm resting lightly on the left side of the occiput and one finger touching the left temple. The impression is ambiguous; the gesture can be interpreted as being both protective and menacing. At the same time, the assemblage of two discrete fragments can be seen as symbolizing the split in Camille's own personality—perhaps the onset of the paranoid schizophrenia, which Rodin intuitively recognized and found deeply upsetting.

Camille's most significant work from the early 1890s is the group known as *The Waltz*, showing a pair of almost naked dancing figures. She made several versions, in various sizes, of this bronze sculpture, which critics unanimously regard as a minor masterpiece.

Whereas the young man is entirely unclothed, his partner wears a robe that swirls around her legs like a train, following the movement of the dance. The upper part of her upper body is exposed, and in view of the theme and the customary practice of Rodin's studio, it can safely be assumed that both dancers were originally sculpted without a single vestige of clothing. This view is corroborated by the fact that Camille was required to dress the figures in order to comply with the requirements for state commissions. However, the woman's skirt and hairstyle strike an interestingly contemporary note and serve to locate the couple in a specific social context, quite unlike the pairs of lovers sculpted by Rodin, whose nakedness is often grounded in pure mythology. The two bodies are entirely immersed in the music and the rhythm of the waltz; the woman nestles against the man's arm encircling her waist, while his face bears down toward her left shoulder, as if he were about to imprint a kiss on her neck. Despite the relative lack of emphasis on actual physical contact, the couple's movements are perfectly harmonized. The whirling motion of the dance is beautifully conveyed. The man is on the point of executing a turn, pivoting on his right leg and slightly raising his left foot to begin a new step. One is also impressed by the subtly graded modeling of the supple back muscles and the radiant skin of both partners, as their bodies swirl over the dance floor in the continually repeated semicircular movement of the waltz. There is little in Camille's previous work to indicate that such an achievement might be forthcoming, and anyone not completely blind is bound to detect certain parallels with the work of her teacher. Rodin's *Eternal Springtime* is an exemplary embodiment of the sense of animated harmony seen in *The Waltz*. Here, the couple is not actually dancing, but as we have already seen, the approach of spring, symbolized by the figure of Zephyr, is portrayed in terms that suggest the idea of dance. In his many groups

Camille Claudel,
The Waltz, 1891-1905

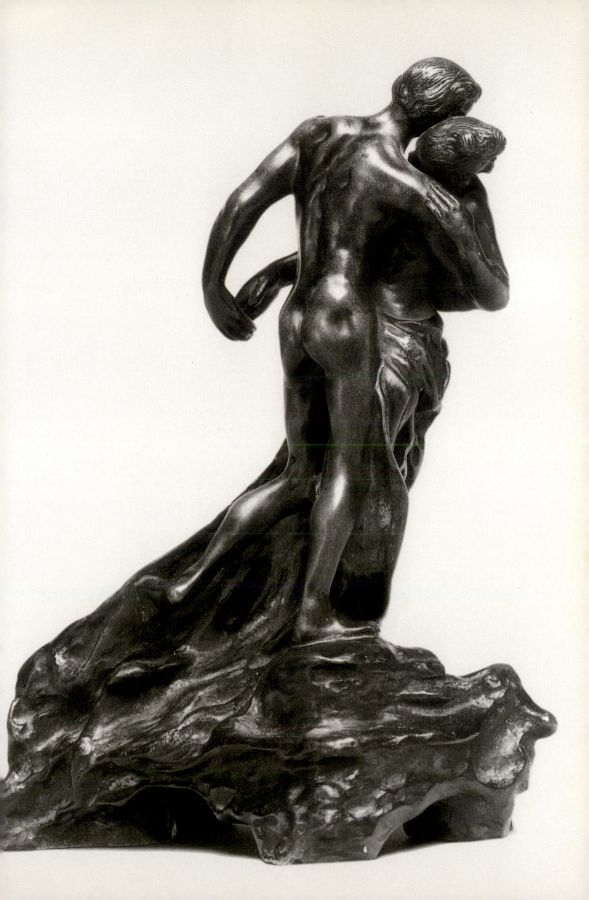

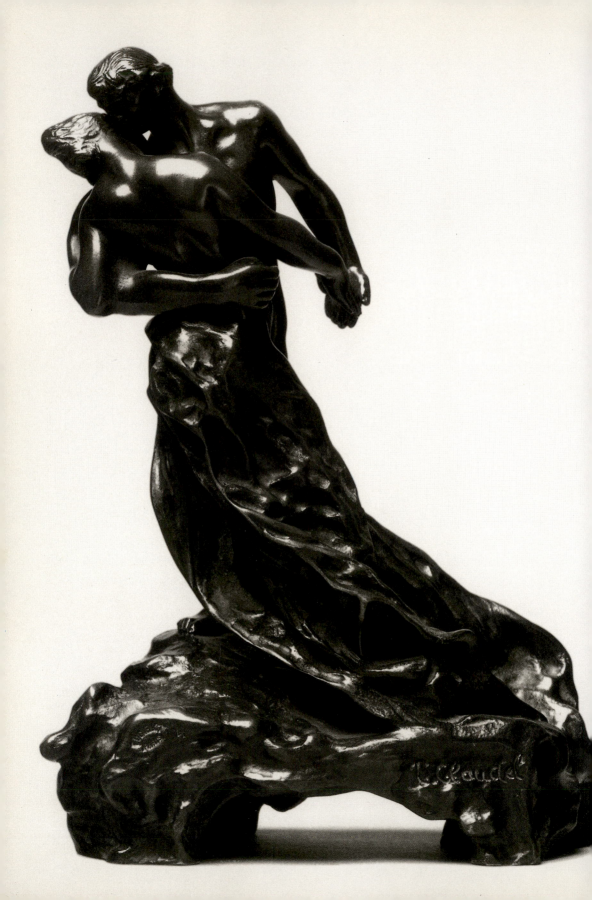

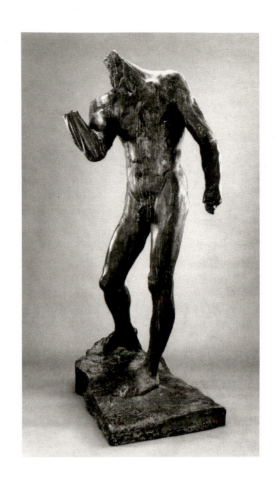

Auguste Rodin, *Study
for the Nude Figure of
Pierre de Wiessant,*
ca. 1886

Camille Claudel,
The Waltz, 1891-1905

of human figures, Rodin generally paid careful attention to rhythm. The composition of *The Burghers of Calais* owes part of its spellbinding effect to the choreographic arrangement of the figures, whose movements are complex and subtly developed. The young man at the edge of the group, turning to one side with his hand raised, is a kind of solitary dancer. Although his dance is not a waltz, but a dance of death, he is the "brother," as it were, of the male figure in Camille's sculpture—in the preliminary study for his torso, this relationship is particularly evident. This influence is crucial to the conception of *The Waltz*. Nevertheless, the latter work is original in so far as it introduces a new motif: the almost trancelike surrender of the figures to the vibrant rhythms of the music. The spiraling motion of the couple, like a spinning top, enables the work to be admired from all sides, thus echoing the idea of the *figura serpentinata* in the theory of Italian mannerism. Made in 1892 and exhibited at the Salon of the following

year, *The Waltz* was Camille Claudel's greatest success. References to over seventy-five casts have been found in various art dealers' records, although it is uncertain whether all these copies were actually made and sold. It was suggested that Camille be awarded a state commission to execute a monumental version in marble, but this proposal, on which she pinned great hopes, never came to fruition. Several editions of the work were produced, in various sizes. Standing approximately thirty-eight inches high, the first version had the dimensions of a substantial statuette; the smallest version was only about half as big. The height is also influenced by the irregular shape of the base. A number of the bronze casts were gilded. Unfortunately, only a few copies still exist.

A Romance with Debussy?

A cast of *The Waltz* is known to have stood on the piano, or the mantel-piece, of the composer Claude Debussy. As a friend of the Claudel family, Debussy was closely acquainted with Camille, who was only two years his junior, and a brief romance ensued in or around 1890. Debussy is said to have played the piano for Camille in his freezing room at his parents' apartment until his fingers became stiff with cold. Although Camille appears to have shown little appreciation of his music, which by the standards of the time sounded so disconcertingly modern, Debussy evidently took a strong liking to the attractive sculptor; she, however, remained as blunt and coarse as ever. In a letter of February 1891 to his friend Robert Godet, Debussy describes a sad parting from an unnamed young woman whom he greatly admired: although the facts of the matter have never definitely been established, this may have been Camille Claudel. The composer complains of the recriminations and harsh words that suddenly rained down out of the blue, following a "bizarre change" in the woman's manner of expression. Her speech, formerly "touching and adorable," had suddenly become violent and aggressive. This account of an abrupt emotional outburst fits exactly with what we know of Camille's personality, and it would appear to be a harbinger of her subsequent psychotic episodes. However, this interpretation poses certain problems. If the letter does indeed refer to her, then it was she, rather than Debussy, who made the break, which would have occurred in the winter of 1890-91. But as *The Waltz* cannot have been made before then, this means that Camille must have presented the sculpture to

Claude Debussy,
Rome, 1885

Debussy at some point after their final separation, but before the work was first exhibited in 1893. This seems somewhat implausible. An alternative explanation is that the woman referred to in the letter was someone else, and that the friendship between Camille and Debussy ended in similar fashion in 1892, the year when Gabrielle Dupont became Debussy's mistress.[21] It is possible that Camille still felt strongly attracted to Rodin—despite the massive age gap between him and Debussy—and that she was reluctant to embark on a new love affair before the relationship with her teacher had run its full course. But this is pure speculation.

It has also been alleged that it was Camille Claudel who first drew Debussy's attention to *japonaiserie*, the contemporary fashion for Japanese art and decoration. This, too, is uncertain: Debussy's circle of friends included several people who admired Japanese art.

The traditional story that Debussy and Rodin were temporary rivals in a contest for Camille's affections is supported by contemporary accounts. Nevertheless, it is possible that the facts were embroidered upon to create a typical piece of artistic legend.

Clotho:
Camille Claudel's Goddess of Fate

It was after the end of her friendship with Debussy that Camille Claudel sculpted *Clotho*, one of her most distinctive figures. In Greek mythology, Clotho is one of the three Fates who control human destiny. She spins the thread of life, which is then cut off by the third of her fellow goddesses.

Again, this work can be interpreted in biographical terms. Seeing her own life as ruled by an inescapable fate, Camille depicts Clotho as an old woman tangled in the thread of destiny which she spins from her own hair. Burdened and blinded by the knotted mass of hair, the figure seems hardly able to stand. Her body is reduced almost to a skeleton, and her head is skewed awkwardly to one side; her features are contorted into the mask-like grimace of a witch, whose oddly vacant gaze, looming out of the shadows, strikes terror into the beholder and conveys a message of evil and calamity. Yet this is the work of a twenty-eight-year-old woman.

Only the most fearful depression could have led Camille Claudel to create such a bleak vision of destiny. When discussing her childhood, we already mentioned Ligier Richier's well-known monument to René de Châlons in Bar-le-Duc, which Camille must have seen as a young girl. It is possible that the memory of this work supplied part of the inspiration for her strange depiction of the goddess of Fate. The knotted, ragged braids and strands of hair—symbolizing the confusion of Clotho's life—form a kind of network or trellis around the skeletal form of her desiccated body. The limestone statue in Bar-le-Duc shows a body which is similarly wasted and reduced almost to a set of bare bones. Richier's work shows a singular degree of bravura in the use of the chisel, and Camille Claudel also carved a marble version of *Clotho* after exhibiting the plaster cast of the superbly modeled figure in 1893 at the Société Nationale des Beaux-Arts, a new secessionist exhibition society that Rodin had helped to found in 1889. The purpose of this exercise was to provide herself with an opportunity to demonstrate her talent for working marble, a skill in which she had reached the pitch of perfection, showing a particular flair for the intricacies of "openwork" carving.

Unfortunately, the marble version of *Clotho* has been lost. Some critics have pointed out resemblances to the work of the fifteenth-century sculptor Donatello, especially to his portrayals of *St. John the Baptist* and *Mary Magdalene*. There are also a number of contemporary parallels. One might refer, for example, to Victor Prouvé's *The Night*. Admittedly, the latter work is not a statue, but a bronze head cast in the form of a dish, with long

Camille Claudel,
Clotho, 1893

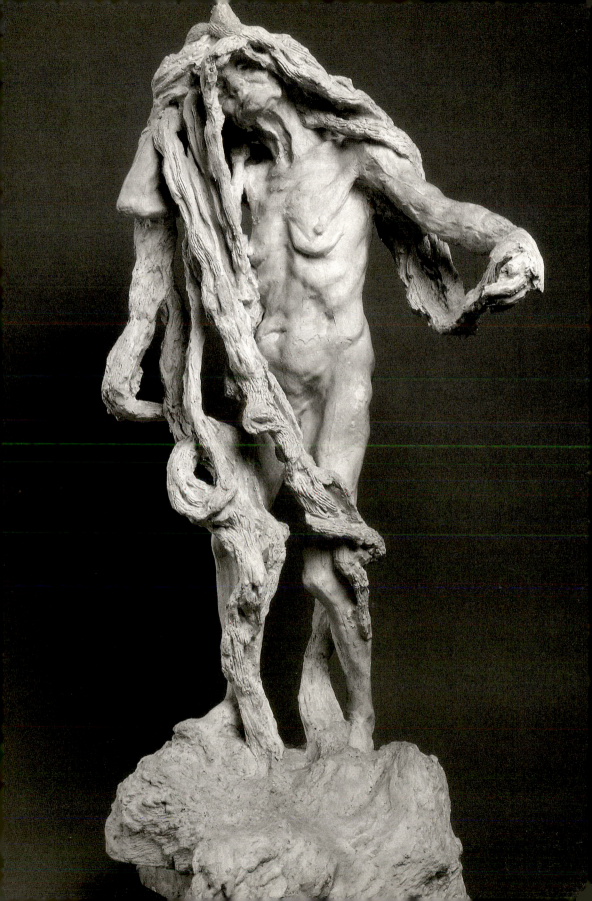

strands of hair into which small figures are set that symbolize various activities and emotions associated with the idea of nighttime: sleep, dreaming, love, birth, jealousy, murder, death, and the anguished hankerings of the lonely. However, despite the difference in form, the treatment of the hair is definitely reminiscent of the tangled threads of destiny in *Clotho*. Prouvé was a friend of Emile Gallé and a leading member of the Ecole de Nancy in Lorraine, one of the groups which gave birth to the French version of Art Nouveau. He exhibited *The Night* at the Champs-de-Mars Salon in Paris in 1894, a year after the first showing of *Clotho*.[22] Could *The Night* have been seen at some previous juncture, before the bronze cast was made in Paris? Of course, it remains debatable whether the two sculptures are actually connected. And although Prouvé's work was influenced by the symbolist reliefs of Rodin's *The Gates of Hell*, some of its features also anticipate the style of Art Nouveau.

The braids of hair that swirl around the figure of Clotho also have a faintly ornamental appearance, hinting at the incipient influence of Art Nouveau. This emerges more clearly from the photographs of the marble version, sculpted in the late 1890s, than from the plaster cast of 1893.

The design for the main body of the figure was produced separately at a somewhat earlier date. Camille's plaster study for the torso, made in 1892,

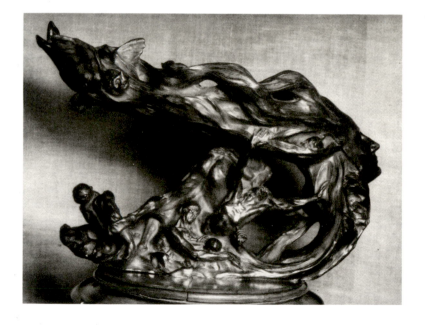

Victor Prouvé,
The Night, 1894

72

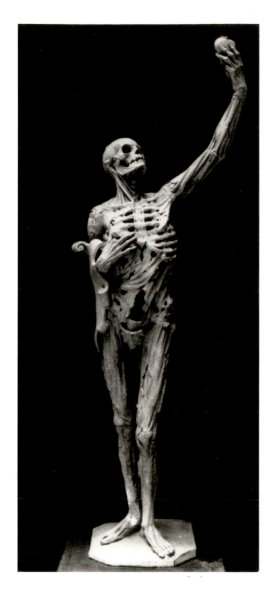

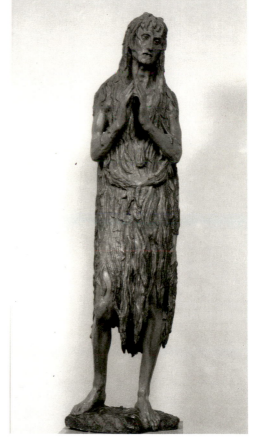

Ligier Richier, statue of Death from the
monument to René de Châlons in the Eglise
St. Pierre in Bar-le-Duc, after 1544

Donatello, *Maria Magdalene*, ca. 1453-55

invites comparisons with *The Helmet-Maker's Wife* (1887), Rodin's starkly realistic portrayal of an old woman, which has been interpreted as a symbol of *vanitas*. The title is derived from a ballad—"Celle qui fut la belle Heaulmière" (She who was once the helmet-maker's beautiful wife)—by the fifteenth-century popular poet François Villon. Here, the woman is not standing, but seated, with her head bent forward to inspect the emaciated remains of her decaying body. Rodin's longtime collaborator Jules Desbois also produced a related work, a group entitled *Death and the Woodcutter* after the fable by La Fontaine.[23] Regrettably, this work was destroyed, and only a photograph of the piece has survived. Desbois, too, portrays death in the guise of a shriveled old woman (in French, the gender of death—*la mort*—is feminine), and he is said to have used the same model, an old Italian woman, as Rodin and Claudel when they were making *The Helmet-*

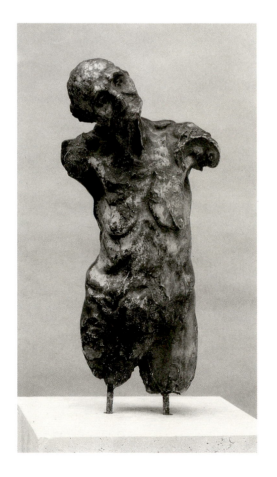

Camille Claudel, *Torso of Clotho*, ca. 1893

Old Woman and young kneeling woman. Detail of the left pilaster of *The Gates of Hell*, before 1884 (bronze after 1925)

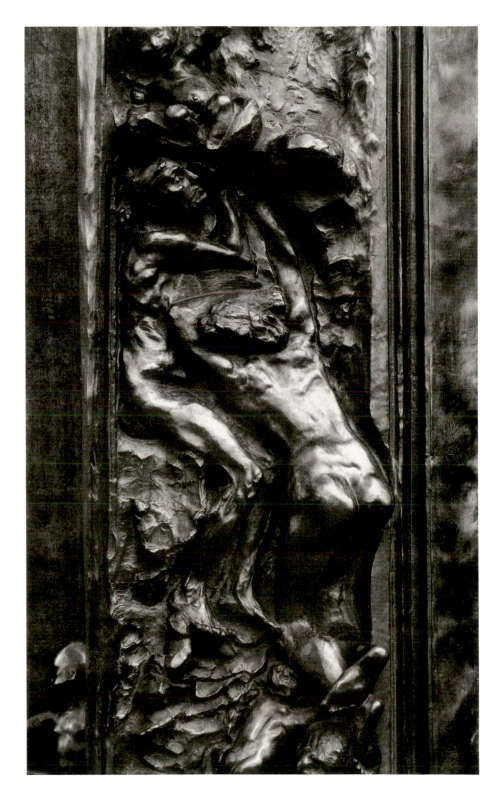

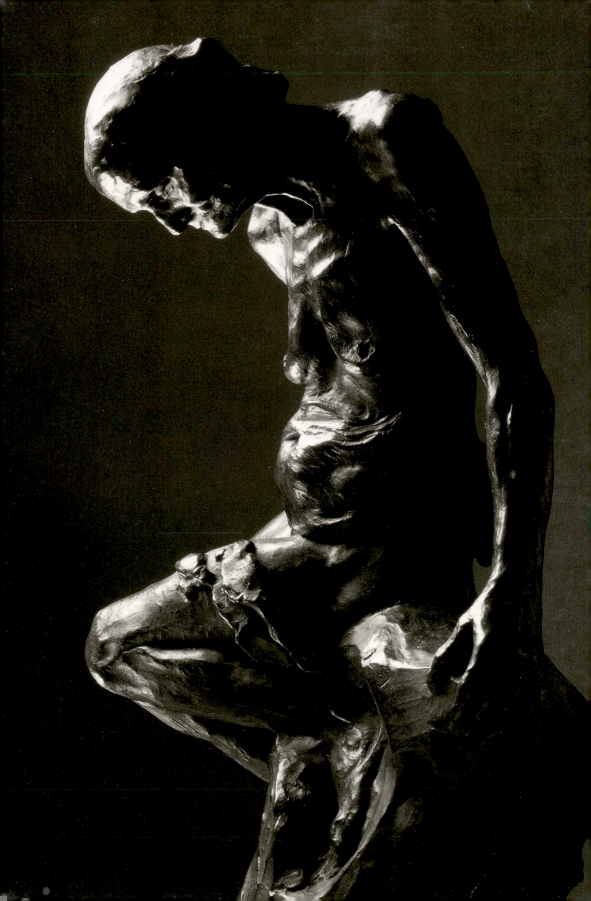

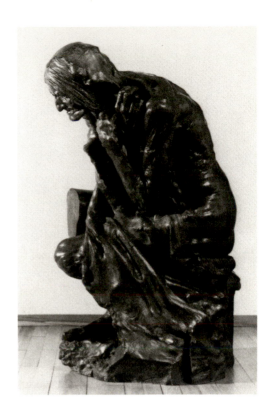

Jules Desbois,
Misery, 1896

Maker's Wife and *Clotho*. However, the earliest appearance of the model is in the pilaster relief on the left-hand side of *The Gates of Hell*, which one must assume to have been made in 1883 or 1884. At this point, Claudel and Desbois were working in Rodin's studio, where they witnessed the completion of *The Gates of Hell*, and they were both familiar with the model. With her help, they produced a number of works which are characteristic of the prevailing Zeitgeist: the bloom of youth is juxtaposed and contrasted with images of physical decay and intimations of mortality. It is within this context that *Clotho* must be seen and evaluated.

Auguste Rodin, *The Helmet-Maker's Wife*, 1880-83

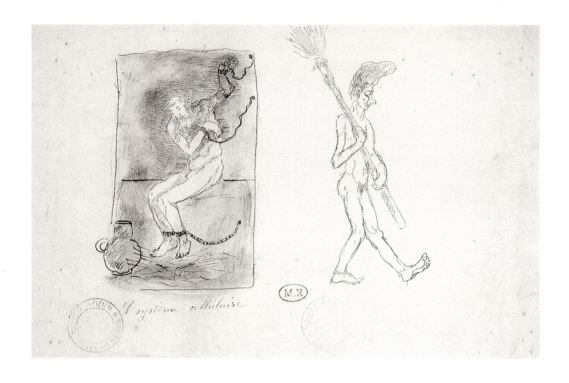

The Fruits of Hatred

On realizing that she could not corral Rodin into a lasting relationship, Camille began to despair. Her attendant feelings of hatred brought forth some odd results—in the shape of a series of satirical drawings with a marked sadistic bent. The dating of these curious sketches is uncertain. It is generally assumed that they were done in 1892, but a later date of origin cannot be ruled out and would in fact seem quite plausible. Done in pen-and-ink with a brown ink wash, the works are now in the collection of the Musée Rodin in Paris. The first drawing bears the title *Le système cellulaire* and shows Rodin sitting in a prison cell—chained hand and foot, and evidently on a bread-and-water regime—while Rose Beuret, armed with a long-handled broom, patrols up and down outside like a vigilant warder. In the second drawing, Rodin and Rose are portrayed as a pair of lovers lying together in bed. Rose's breasts are shrunken and withered, she has an ugly profile with a bulbous nose, and her index finger is raised, admonishing Rodin to fulfill his amorous duty. With the third drawing, titled *Le Collage*, Camille's imagination reaches a peak of distortion, fueled by her feelings

Camille Claudel,
Prison Conditions,
1892 (?)

78

of despair. Apart from its usual meaning (i.e. "gluing together"), the French word *collage* is a pejorative slang term for "love affair," implying that the partners are particularly close.) Here, Rodin and his mistress are literally stuck together, joined at the rear like a pair of copulating dogs surprised *in flagrante*. Rose is squatting on all fours, with her head and breasts hanging down toward the ground, while Rodin is trying to pull himself free by clinging to a tree trunk, but it is obvious that his efforts are in vain. He and his partner are doomed to remain united.

This crude image probably owes part of its inspiration to one of Rodin's sculptures, *The Centauress*, in which the human half of a female centaur is seen struggling to break free of her lower, animal half. The plaster version of this work was probably made in 1887 or, at the latest, in 1889, which means that it took shape under Claudel's eyes. Its theme is central to Rodin's philosophy of life, with its notion that the human soul is a prisoner to the flesh, to the "animal" nature that prevents the spirit from attaining its lofty goals.[24] The same view of the human condition is found in *The Thought*, Rodin's portrait of Camille showing her head lodged in a block of marble. As early as the mid-eighteenth century, the Swiss poet and natu-

Camille Claudel,
The Awakening
(Sweet Remonstrance),
1892 (?)

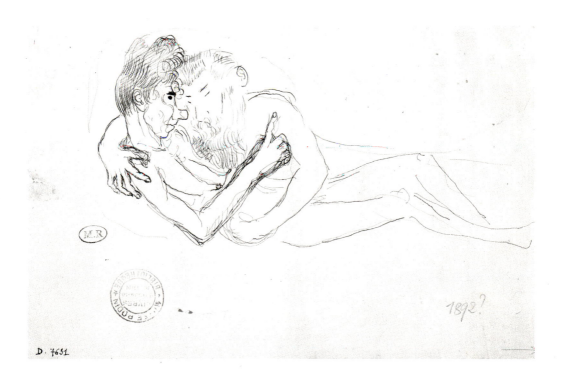

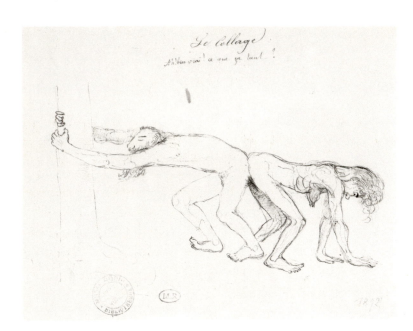

ralist Albrecht von Haller (1708-77) summed up this eternal dualism of body and soul in his characterization of mankind as "a wretched cross between angel and beast," a phrase which Schiller subsequently picked up and varied in his medical dissertation.

It was an inspired idea on Rodin's part to symbolize the rift between the spiritual and the animal by combining the body of the horse from his equestrian statue of the Chilean soldier General Lynch (ca. 1886) with the torso of a woman and a separately made pair of arms to create the figure of a female centaur. He then completed the work by adding the head of one of the sons from the *Ugolino* group. The same head also appears in a further work known as *Head of Sorrow*, and was part of the early stock of forms for *The Gates of Hell*. The exact dating of *The Centauress* has recently become a subject of controversy. Whereas George Grappe gives the date of completion as 1887, Nicole Barbier surmises that the sculpture may not have been made until after the turn of the century, when assemblages of this kind became a common feature of Rodin's work. However, the technique of combining sections of existing figures is also found much earlier. In 1882, for example, Rodin applied the principle when working on *The Gates of Hell*: the group *Je suis belle* at the top of the right-hand pilaster is a composite form made up of parts that originated at different times.

From 1900 onward, Rodin made ever-bolder use of the technique of assemblage. Certainly, the marble version of *The Centauress* cannot have

been carved before 1901 or thereabouts.[25] However, it must be borne in mind that the theme is closely linked with that of *The Thought*, and Camille Claudel's drawing from the 1890s evidently refers to the work. The probable explanation is that Rodin made a plaster study for *The Centauress* in the late 1880s or early 1890s and propped up the outstretched arms with some form of improvised support to prevent the cast from falling apart before the work was executed in marble. This would tally with the image of the tree trunk in Camille's drawing, which Rodin is clutching in an effort to liberate himself from his mistress, with his hands forming the same gesture as in the sculpture of the female centaur. The drawing also includes a caption, which reads "Le Collage—Ah! ben vrai! Ce que ça tient!" ("The *collage*—Oh yes, it really does stick!") The words are evidently placed in the mouth of Rose and explicitly comment on the impossibility,

Auguste Rodin,
The Centauress,
1901-4

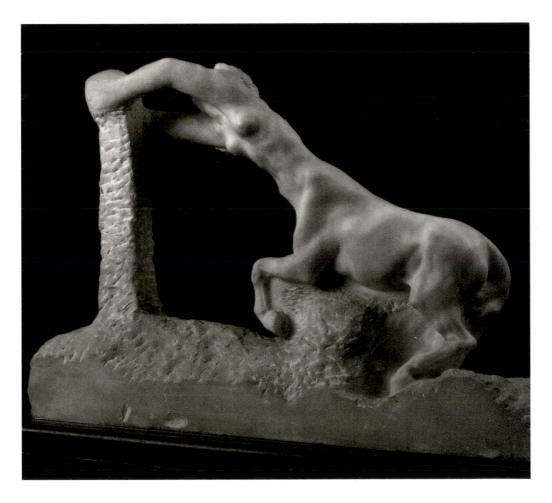

translated by Camille into pictorial terms, of dissolving a liaison in which the partners are physically glued together.

It is clear from these cartoons that Camille still retained a strong affection for Rodin. She portrays him as a helpless prisoner, an object of pity rather than scorn, and the element of caricature in the depiction of his plight is far less marked than in the drawing of Rose Beuret, the "old hag" whom Camille sought to displace. Camille's imagination is playing a despairing game, trying to find some way of breaking up this "unnatural" relationship. Yet at the same time, she realizes that this is impossible, although she finds it incomprehensible that the liaison should prove so stable and permanent.

L'Age mûr: Symbol of the Eternal Triangle

It gradually dawned on Camille that Rodin was not going to fulfill his promises toward her, and this bitter realization supplied the theme for one of her major works, the intriguing group known as *L'Age mûr*, which, once again, contains a strong autobiographical element. The title is usually translated as *Maturity* or *The Age of Maturity*, but this does not quite convey the spirit of the original. In French, *mûr* has the double meaning of "mature," in a positive sense, but also of "aged" or "overripe," like fruit which is already falling off the branch.

Let us begin by looking at the first version, in plaster, which was donated to the Musée Rodin by Paul Claudel in 1952. The group comprises three naked figures: an old woman, a middle-aged man, and a young woman in the pose of a kneeling supplicant. The latter figure can be seen as a symbolic self-portrait by the artist, although the features are not Camille's own and the slim body is that of a young girl. She is looking up adoringly toward the man and pressing his left hand to her breast. He, however, has turned away to place his arm over the shoulder of the old woman advancing toward him, who has caught him by the waist with one arm, while her free hand, hanging by her side, is bunched up into a fist. This gesture signifies her energy and determination to defend the man as her legitimate possession, the chosen comforter of her declining years, against the temptations of her younger rival. The man seems to be faltering or stumbling. At all events, his gait is unsure, and although the upper part of his body is bent backwards and sideways in the direction of his young

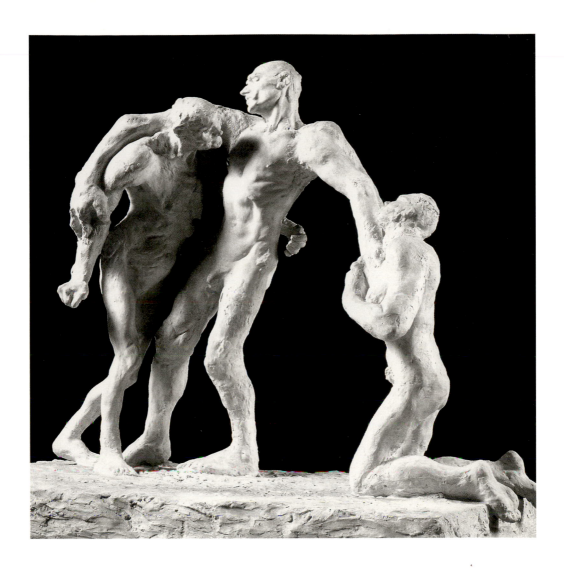

Camille Claudel,
L'Age mûr, ca. 1894.
First maquette

admirer, who is trying to pull him toward her, the old woman has plainly reasserted her hold on him. This image of a man torn between two women—one young, one old—encapsulates the drama of Camille Claudel's life. With her ugly, wrinkled features (echoing those of the figure in *Clotho*) and empty, slackly pendulous breasts, the woman is a caricature of the aging Rose Beuret. Here, too, there is no direct portrait resemblance to the "original," nor is there an obvious likeness between Rodin and the male figure, who is simply an average middle-aged man. Clearly, however, the work is a symbolic embodiment of the ménage à trois between Rodin, Camille Claudel, and Rose Beuret. Paul Claudel spelled this message out in a commentary written many years later.

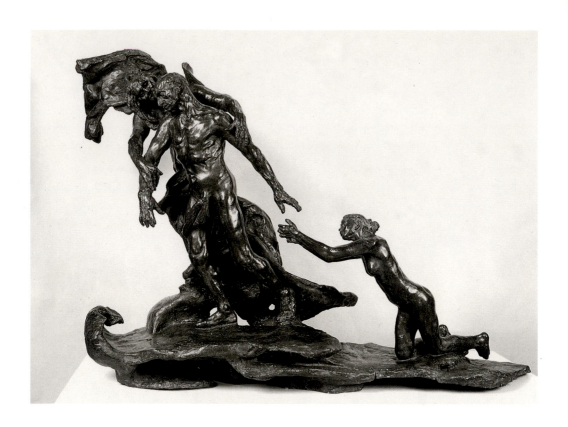

Camille Claudel,
L'Age mûr, 1898.
Second maquette

In the second and final version of the work, which was completed in about 1898—although the bronze cast was not exhibited until 1903—the relationship between the young kneeling woman and the man wavering in the center is modified in a way that takes the story an important step further. All physical contact between the two has been suspended. The woman's arms are outstretched in a meekly imploring gesture, but the man's trailing hand has already slipped out of her grasp. Spurned and left alone to mourn, she will never be allowed to touch her lover again.

As well as a number of preliminary studies, Camille Claudel also made a separate and distinct version of this kneeling figure: a statuette titled *God Flown Away*, which was only recently cast for the first time in bronze. Here, one of the striking points of contrast with the figure in *L'Age mûr* is the heavily braided appearance of the woman's hair. The work is a poetical evocation of Camille's suffering, soliciting the viewer's pity for the fate of a woman who was quite literally losing her wits.[26] There is also a second variant, known as *The Implorer*. Several bronze casts of this were made in 1900 by Eugène Blot and exhibited on three occasions during Camille's

lifetime: in 1903, 1905, and 1936. The casts were miniatures, standing only eleven inches high. In 1903, Blot also made a miniature version of *L'Age mûr*, with a height of $23\,^{1}/_{2}$ inches, and it was in this form that the work was shown in Paris in 1907 and 1908.

An unusual feature of *L'Age mûr* is the composition. The figures are set on a base divided into two superimposed sections of differing height to form a triangle that ascends from right to left, with the feet of the supplicant at the bottom right-hand corner and the old woman's whirling cloak marking the apex. Thus, the young woman's body and raised arms, the hesitantly trailing left arm of the man in the center, and the left arm of the old woman around his shoulders together describe an undulating line that moves steadily upwards to the folds of the old woman's garment and then suddenly plunges downward in an almost perpendicular movement on the left-hand side of the triangle. This, in turn, is echoed by the erect posture of the man and the old woman and by the vertical position of their right arms. Looking at this three-cornered composition, the image which springs to mind is that of a pediment divided in half. The figures, lined up in a row against a flat background, are reminiscent of the tympanum friezes that adorn Greek and Roman temples, and it is as if we were seeing the right-hand section of just such a frieze. Thus the group has the character of a relief, with no real sense of spatial depth. The positioning of the old woman, who is standing partly behind the man, generates a slight staggering effect, but otherwise, the composition is predominantly two-dimensional, designed to be seen from a single, frontal vantage point. This lends the work a pronounced narrative character. In other words, it is a dramatic story unfolding sequentially from right to left, beginning with the young woman kneeling imploringly on the ground and ending with her older rival, who is snatching away the man in the manner of a malevolent sorceress, with her cloak billowing around her head like a menacing cloud.

Middle-Aged Man and His Two Mistresses, engraving, eighteenth century

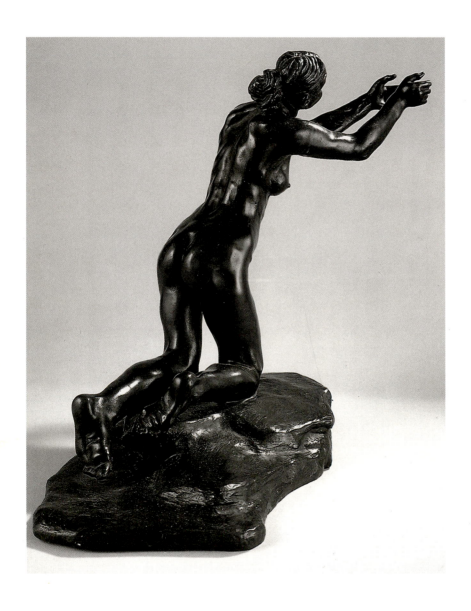

Camille Claudel, *The Implorer*, 1900

Camille Claudel, *God Flown Away*, 1894

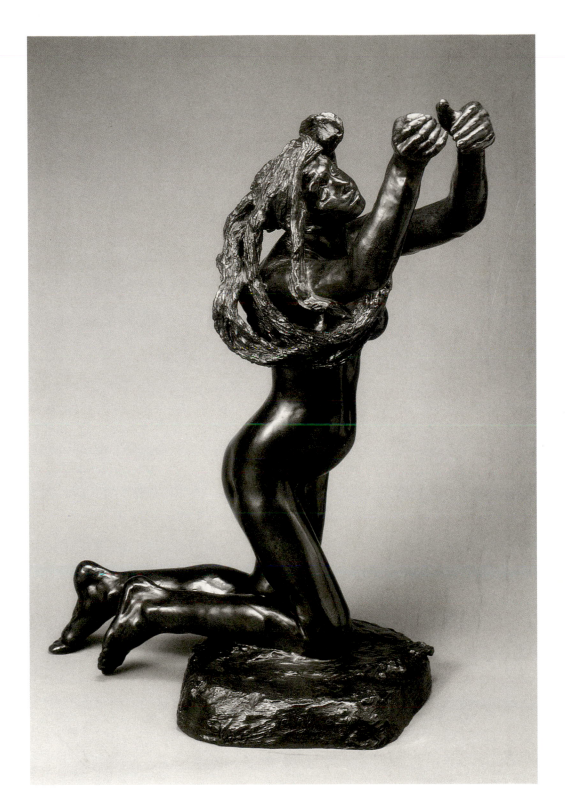

As far as the modeling of the bodies is concerned, the figures are fashioned in a style that can safely be called "school of Rodin." The composition, however, is influenced less by Rodin, whose group sculptures tend to be characterized by a closer, more compact arrangement of the component elements. This different approach to the spacing of the figures is an original feature of Camille's work, which is also found in *The Gossips* and *The Wave*, two smaller-scale ensembles dating from the same period. The bodies retain their independence and are not directly joined or intertwined like Rodin's pairs of lovers. Yet Rodin, too, portrayed *The Burghers of Calais* as separate individuals; each of the six citizens stands alone and isolated as he prepares to lay down his life. This was obviously the model that guided the design of Camille's group of three figures, but as the sketch in her letter already indicates, she was unable to compress the relatively flat, triangular composition into a form that would give the work a greater plastic and spatial intensity.

Because of its two-dimensional aspect and the large amount of empty space between the figures, the full-scale version of *L'Age mûr* appears to lack concentration, although this is partly offset by the movement of the man and the old woman and by the way that their bodies lock together. These elements lend the work a certain rhythmical feel similar to that found in *The Waltz*. Inevitably, the theme of rhythm and harmony also involves discord.

It would seem that *L'Age mûr* did not meet with a particularly enthusiastic reception. Moreover, its autobiographical content went largely unrecognized. The sculpture was probably regarded as merely a symbolic reworking of the traditional story of a man caught between two women and, at the same time, as a variation on the "ages of man" theme. The familiarity of the subject to the Paris art world is indicated by illustrations from the past, such as the small copper engraving from an eighteenth-century almanac reproduced on this page. Bearing the caption "L'homme entre deux ages et ses deux maîtresses" (The Middle-Aged Man and His Two Mistresses), the engraving shows a society beau with two women: an older, refined lady standing on his left, and a young woman seated on his right. Both women have laid a hand on the man's head, as if to document their respective claims on his affections. Although the setting and decor belong to an earlier era, the situation is the same as in Camille's group of figures. However, it remains an open question whether images of this kind had any direct influence on the conception of *L'Age mûr*.

Small-Scale Sculptures in
Claudel's Late Work

In a letter to her brother, written in the winter of 1893-94, Camille Claudel refers to several new projects on which she is working. Describing her plans with the aid of small thumbnail sketches, she particularly emphasizes her aim of moving away from Rodin's approach to sculpture. The works in question are to be based on scenes from everyday life. Under the title *The Confidence*, Camille refers to a group of three women sitting together and listening intently to the words of a fourth woman. Camille also mentions in the letter that she intends to clothe the figures instead of leaving them naked, the idea being that the work should reflect everyday reality. This, too, represents a departure from Rodin's usual practice. A further factor in Camille's decision was probably the adverse reaction of the state authorities to the naked dancers in the first version of *The Waltz*, which was felt to offend propriety.

Letter from Camille Claudel to her brother containing one of her first sketches of *L'Age mûr* (detail), ca. 1893

Camille Claudel,
The Gossips, 1897

Camille evidently revised her plans. In the first version of the group, modeled in 1894, the figures are naked. A second version followed in 1895, when the figures were cast in bronze by Eugène Blot and mounted in front of a marble screen, shaped like a corner of a rock, which highlights the confidential nature of the women's conversation. The work was also given a new title: *The Gossips* (in French: *Les Causeuses* or, alternatively, *Les Bavardes*). Various commentators have surmised that the choice of this commonplace theme was at least partly motivated by Camille's own experiences as a victim of petit-bourgeois gossip and scandalmongering, which she must have found increasingly upsetting. One can almost hear the whisperings of the young women as they sit huddled together, exchanging snippets of rumor: "Have you heard the latest? People are saying that.... No, really? Well, I never...." The small figures are delicately modeled, and one welcomes the decision not to clothe them after all. Looking at the supple forms, one inevitably senses the hand of a sculptor trained in Rodin's studio. The theme, however, is Camille's own idea, and it is handled in a very human way, observing an aspect of everyday behavior with an ironic detachment. A few years later, Camille made a second version of the work; this was followed in 1897 by the final version, in which the bronze figures are seated in front of a wall of onyx, enclosed by a low bronze frame. Both of these later versions are now in the collection of the Musée Rodin in Paris.

The final version of *The Gossips* is very small: the wall of onyx stands about 17 1/2 inches high, and the female figures just over three inches. Together with the preciousness and multicolored appearance of the material, the miniature scale of the work lends it the air of an exquisite *objet d'art;* and this, indeed, is how the sculpture was seen when Camille exhibited it in 1897, at the time when the Art Nouveau movement was flourishing.

The following year, she made a further group, titled *The Wave* or *The Bathers*, which mixes materials in the same way. Three little female bathers—cast in bronze, and again, beautifully modeled—are set in the dish-like form of an onyx wave. Clasping each other by the hand, the naked figures are waiting in a semi-crouching position, ready to leap into the wall of water which is about to break over their heads and on which their gaze is focused in an expression of playful, yet slightly anxious anticipation. Given Camille's own fondness for swimming, it can be assumed that this motif, too, derives from her personal experience. As in other works, there is also a certain sense of threat. The force of the gigantic wave is such that the three girls could easily be buried under the mass of water and swept away, despite the firm foothold offered by the shore, which is barely covered by the shallows in which the girls are standing. The cresting swell hangs above their heads like an instrument of fate, as if disaster were about to strike. It has been pointed out that the vogue for Japanese art had reached a new peak at the time when this work was made; and we know that Camille and her Parisian friends had a great admiration for Japanese woodcut prints, especially for Hokusai's *The Great Wave*, with Mount Fuji in the background. However, it should be remembered that Rodin's oeuvre also contains a relatively small group with the same title as Camille's sculpture, showing two pairs of female figures floating and rocking back and forth in the water. This work was probably modeled in 1887, and it would seem that a plaster cast was exhibited in 1889 in the Monet-Rodin exhibition at the Galerie Georges Petit in Paris; the marble version was executed in 1901 by the artisan Garnier.[27] Rodin also explored this theme in several other groups of nymphs and sirens. But once again, unlike Rodin, Camille Claudel sets the figures in her work apart from one another. Although they are holding hands, they are very much separate and discrete.

As in *The Gossips*, the figures are enclosed in a kind of protective shell which has a spatially defining effect. Here too, the precious material and the colors give the work the appearance of a superb piece of decorative craftsmanship, an impression which is heightened by the delicate modeling of the naked bodies and the buoyant sweep of the onyx wave.

Between about 1890 and 1905, another of Rodin's pupils, Jules Desbois, was making small allegorical sculptures and Art Nouveau bronze vessels

Camille Claudel,
The Wave, 1900

featuring decorative scenes peopled by young girls, sirens and fauns. In 1896, Desbois was invited to exhibit a selection of them at the salon of the Société Nationale des Beaux-Arts. The exhibition, which included thirty-three of Desbois' small-scale sculptures, attracted a great deal of attention. This was the great age of Art Nouveau design and decoration. In the field of ornamental sculpture, the masters of the movement included—as well as Desbois—the sculptors Jean Dampt, Alexandre Charpentier, Moreau-Nélaton, and Rupert Carabin, who regularly exhibited their work in Paris. From 1891 onward the annual spring salon of the Société Nationale des Beaux-Arts featured a separate section devoted to the decorative arts.

This context, which previous commentators have largely ignored, is an obvious point of reference for the assessment of Camille Claudel's small-scale sculpture, especially with regard to the works that combine several materials and colors. Here, we find the artist experimenting in an area which was perhaps better suited to her talents than monumental sculpture. By continuing to focus her main ambitions on the latter, she ultimately led herself into a creative impasse. The only monumental group which she managed to execute in marble—*Perseus and the Gorgon*, made in 1902, and well over six feet high—appears strangely shallow and conventional.

Auguste Rodin,
The Wave, before 1887

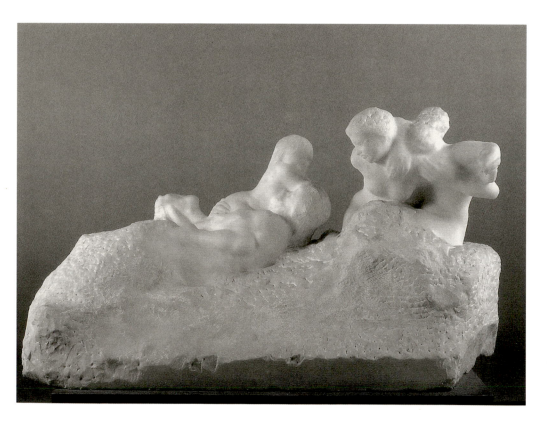

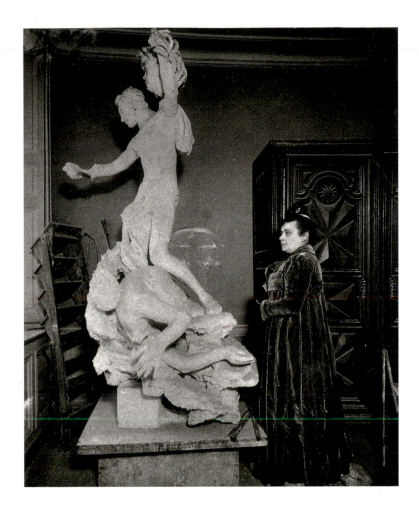

Camille Claudel at work on her plaster maquette of *Perseus and the Gorgon*, ca. 1898

Perseus and the Gorgon: Camille's Swan Song

One of the best-known renderings of this motif is Benvenuto Cellini's bronze statue (1545-54) in Florence, showing the victorious Perseus with the serpent-wreathed head of the Gorgon, the evil monster whose gaze had the power to turn people into stone. Triumphally holding the severed head aloft, Perseus is cast in the role of a Renaissance hero who has succeeded in vanquishing the demons of myth and superstition. Rodin addressed the same theme in a small bronze figure, just under twenty inches high, which was made between 1884 and 1887 in connection with the studies for *The Gates of Hell*. As in Cellini's sculpture, the naked figure of Perseus is shown standing with the Gorgon's decapitated body at his feet. Averting his eyes

95

to escape the monster's gaze, which still poses a deadly threat, he is holding her head by the serpentine hair and preparing to cast it into the abyss.

Camille Claudel was naturally familiar with this rendering of the motif, and she endeavored to find an alternative solution. In doing so, she took an essentially retrograde step, moving back toward the formal approach of Cellini. She also shows Perseus brandishing the Gorgon's head like a trophy, but in his right hand he holds the polished shield which he used as a means of taking aim at her neck without having to confront her eyes. (The metal body of the shield is missing from the marble version of the statue: only the handle and strap can be seen.) This detail taken from the mythical story was designed as a particular feature of the work, the intention being that the reflection from the mirror-like surface of the shield should be visible in the Gorgon's face. Perseus himself is a somewhat effeminate-looking, almost androgynous youth, whose gaze appears to be fixed on the shield, checking to ensure that the reflection is directly focused on the Gorgon's eyes, so that she will turn herself into stone by seeing her own

Camille Claudel, *Perseus and the Gorgon*, 1902. Detail

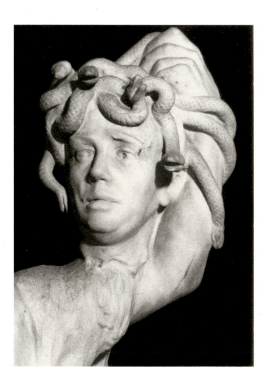

Camille Claudel, *Perseus and the Gorgon*, 1902

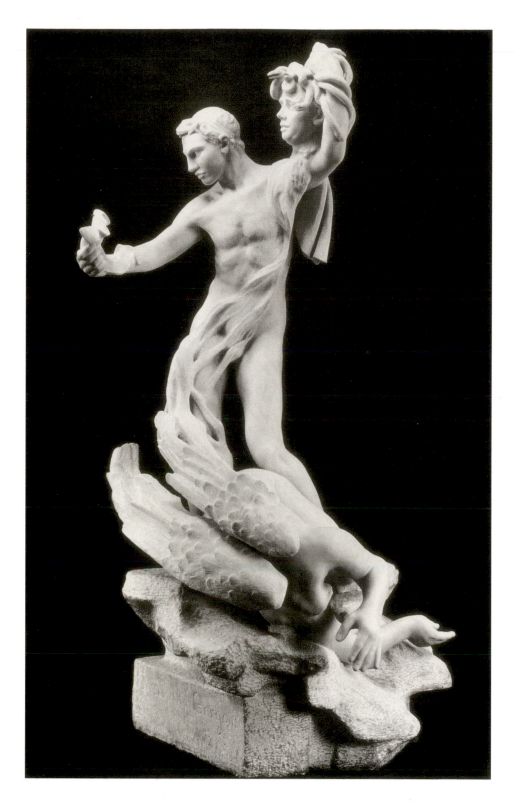

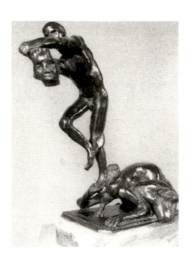

Auguste Rodin,
Perseus and Medusa,
1887

mirror-image. This is an ingenious narrative twist, but the action is perhaps a little too complex for the viewer to follow. It is also oddly inconsistent, since Perseus is endangering himself by looking at the shield. Intentional or not, the anomaly is muddling. Still more confusing is the fact that, as various critics have remarked, the Gorgon's face conjures up two distinct associations. The image not only recalls the contemporary photographs of the rapidly aging Camille; it is also reminiscent of Rodin's *Rose Beuret*, executed in marble by his assistant Antoine Bourdelle in 1898 after a mask which Rodin originally made in about 1880. The latter resemblance can scarcely be coincidental, and it endows the head with a meaning whose psychological implication is bleak in the extreme. Interpreted literally, the message is that Camille wishes to kill her rival and at the same time to extinguish her own life. She is committing murder and suicide in effigy.

The mannerist form of the marble sculpture is in keeping with the style of the more or less life-size portraits that Camille made between 1897 and 1898 for the same patrons, Comte Christian de Maigret and his wife. Following the fashion, prevalent in the second half of the nineteenth century, for mock-historical themes and settings, Maigret commissioned a bust of himself in the costume of the reign of Henri II, i.e., the mid-sixteenth century. By its very nature, such a commission was bound to have a retarding influence on the works concerned. Although Camille's immediate reason for acceding to her patron's wishes was lack of money, the fact that she gave in so easily is a telling indication of the artistic conflict in which she was embroiled at the time. She was struggling to find a new form of expression and was evidently torn between several different options. Her "neomannerist" leanings are also documented by her last original bronze sculpture, *The Flute Player*, which was cast in 1904 by Eugène Blot, who

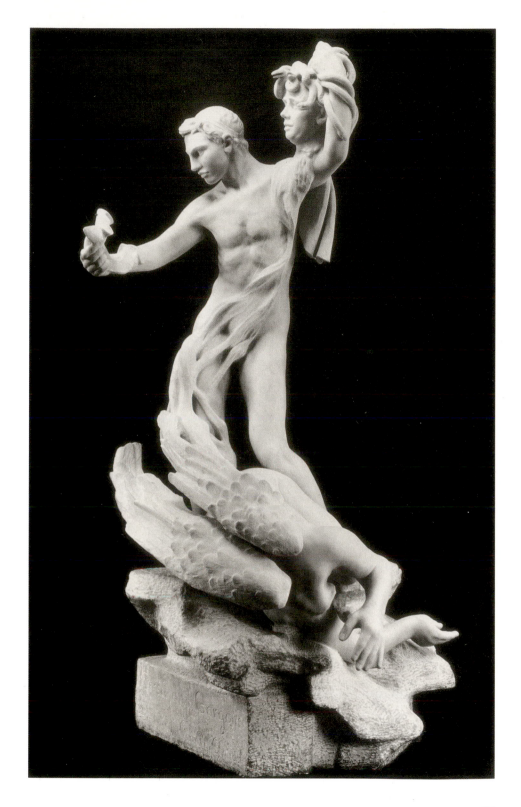

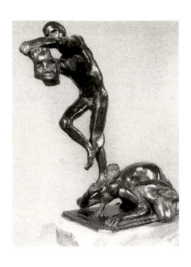

Auguste Rodin,
Perseus and Medusa,
1887

mirror-image. This is an ingenious narrative twist, but the action is perhaps a little too complex for the viewer to follow. It is also oddly inconsistent, since Perseus is endangering himself by looking at the shield. Intentional or not, the anomaly is muddling. Still more confusing is the fact that, as various critics have remarked, the Gorgon's face conjures up two distinct associations. The image not only recalls the contemporary photographs of the rapidly aging Camille; it is also reminiscent of Rodin's *Rose Beuret*, executed in marble by his assistant Antoine Bourdelle in 1898 after a mask which Rodin originally made in about 1880. The latter resemblance can scarcely be coincidental, and it endows the head with a meaning whose psychological implication is bleak in the extreme. Interpreted literally, the message is that Camille wishes to kill her rival and at the same time to extinguish her own life. She is committing murder and suicide in effigy.

The mannerist form of the marble sculpture is in keeping with the style of the more or less life-size portraits that Camille made between 1897 and 1898 for the same patrons, Comte Christian de Maigret and his wife. Following the fashion, prevalent in the second half of the nineteenth century, for mock-historical themes and settings, Maigret commissioned a bust of himself in the costume of the reign of Henri II, i.e., the mid-sixteenth century. By its very nature, such a commission was bound to have a retarding influence on the works concerned. Although Camille's immediate reason for acceding to her patron's wishes was lack of money, the fact that she gave in so easily is a telling indication of the artistic conflict in which she was embroiled at the time. She was struggling to find a new form of expression and was evidently torn between several different options. Her "neomannerist" leanings are also documented by her last original bronze sculpture, *The Flute Player*, which was cast in 1904 by Eugène Blot, who

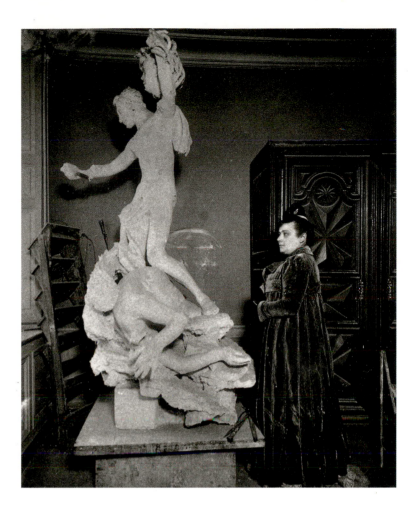

Camille Claudel at work on her plaster maquette of *Perseus and the Gorgon*, ca. 1898

Perseus and the Gorgon: Camille's Swan Song

One of the best-known renderings of this motif is Benvenuto Cellini's bronze statue (1545-54) in Florence, showing the victorious Perseus with the serpent-wreathed head of the Gorgon, the evil monster whose gaze had the power to turn people into stone. Triumphally holding the severed head aloft, Perseus is cast in the role of a Renaissance hero who has succeeded in vanquishing the demons of myth and superstition. Rodin addressed the same theme in a small bronze figure, just under twenty inches high, which was made between 1884 and 1887 in connection with the studies for *The Gates of Hell*. As in Cellini's sculpture, the naked figure of Perseus is shown standing with the Gorgon's decapitated body at his feet. Averting his eyes

95

to escape the monster's gaze, which still poses a deadly threat, he is holding her head by the serpentine hair and preparing to cast it into the abyss.

Camille Claudel was naturally familiar with this rendering of the motif, and she endeavored to find an alternative solution. In doing so, she took an essentially retrograde step, moving back toward the formal approach of Cellini. She also shows Perseus brandishing the Gorgon's head like a trophy, but in his right hand he holds the polished shield which he used as a means of taking aim at her neck without having to confront her eyes. (The metal body of the shield is missing from the marble version of the statue: only the handle and strap can be seen.) This detail taken from the mythical story was designed as a particular feature of the work, the intention being that the reflection from the mirror-like surface of the shield should be visible in the Gorgon's face. Perseus himself is a somewhat effeminate-looking, almost androgynous youth, whose gaze appears to be fixed on the shield, checking to ensure that the reflection is directly focused on the Gorgon's eyes, so that she will turn herself into stone by seeing her own

Camille Claudel, *Perseus and the Gorgon*, 1902. Detail

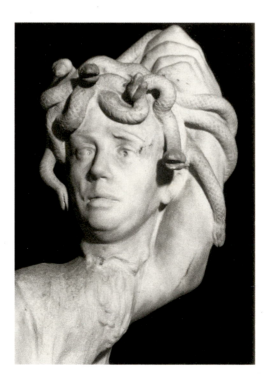

Camille Claudel, *Perseus and the Gorgon*, 1902

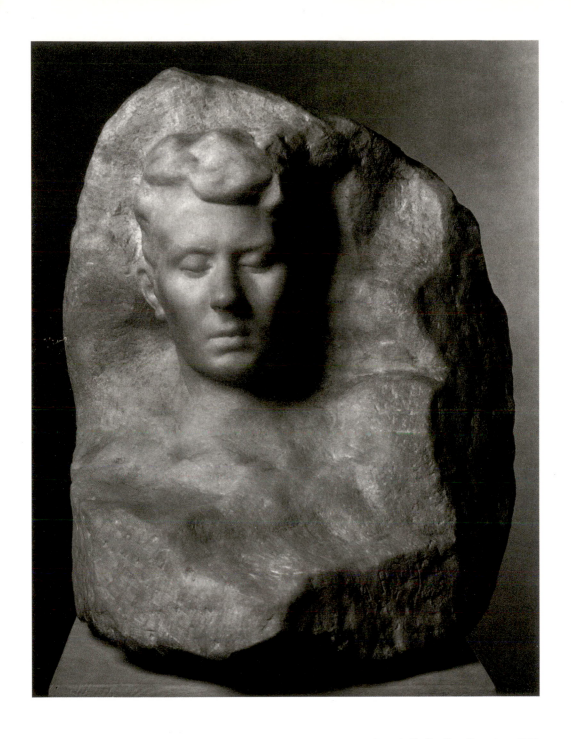

Auguste Rodin, *Rose Beuret*, ca. 1898

still continued to believe in her mission as a sculptor and staged two further individual exhibitions of her work in 1905 and 1908. Seated on a tree-stump, with her knees slightly raised, the almost naked girl is completely absorbed in the music issuing from her instrument; her eyes are closed in an expression of rapt concentration. The position of the arms and hands is carefully observed, and the slender fingers holding and playing the flute are shaped with particular refinement. Together with the raised elbows and the incline of the beautiful head, they form a kind of figure-within-a-figure, complementing the graceful and complexly animated body with the scarf fluttering gently around its shoulders. The delicate figure of the flute player could be seen as a gesture of tribute to Debussy, were it not for the fact that Camille's friendship and fleeting romantic involvement with the composer had already ended at least ten years earlier in 1891. Again, one cannot avoid noting the stylistic retrogression, as if Claudel were harking back to the models of her youth, before her first meeting with Rodin. Paul Dubois' *Florentine Singer of the Quattrocento*, made in 1865, suggests itself as a possible point of comparison.

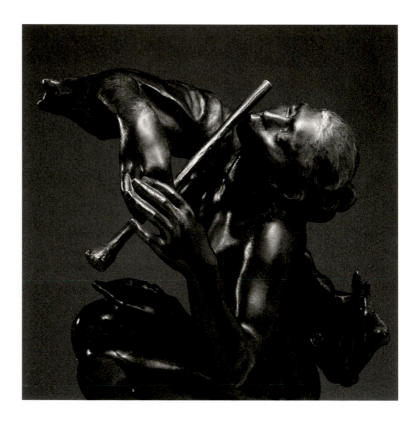

Camille Claudel,
The Flute Player (The Little Siren), 1904

The Work of Camille Claudel:
An Overall Assessment

It is difficult to arrive at a balanced judgment of Camille Claudel's qualities as an artist. Her biography continually intrudes into the foreground, and with it, the tendency to see her as an unfortunate victim of circumstance whose work should now be given wider recognition in order to remedy the injustices of the past. Certainly, one must admire her talent for portraiture and her exceptional gifts as a modeler of nude figures and groups. She was a fine marble sculptor, and several of her symbolist creations are indeed substantial works of art. Nevertheless, she remained for many years in the shadow of Rodin, the teacher whom she initially admired and loved but gradually grew to hate. As she well knew, and fully admitted, Rodin was the greatest sculptor of his generation. And when she at last tried to break free of his massive influence, she proved incapable of making the transitional leap that might have led to genuine originality and independence. Her story has to be compared with that of other artists—male *and* female—who began their careers from the same starting-point. Every artist who worked with Rodin found it difficult to cast off the oppressive burden of his authority. Antoine Bourdelle is a case in point. Born in 1861, Bourdelle was three years older than Claudel. After a brief and disappointing period of study at the Academy, he joined Rodin's studio as an assistant in 1895 and reached the age of nearly forty before discovering his own distinct form of sculptural expression, as documented in his *Apollo*, made in 1901.

A second example is furnished by Jules Desbois, a sculptor whom we have already mentioned several times. Desbois was born in 1851, which made him only ten years younger than Rodin, or, vice versa, only about ten years older than Bourdelle, Maillol, and Claudel. As a student at the Ecole de Beaux-Arts, he had been trained in the conventions of neoclassicism, and it took him some time to realize how sterile the official academic approach to the teaching of sculpture had become. The scales fell from his eyes in 1878, when he first encountered Rodin. Even before Rodin was awarded the commission for *The Gates of Hell*, Desbois became his enthusiastic supporter and assistant, and his loyalty persisted right up until the master's death in 1917. Desbois only attained real independence and originality in two limited areas, located at opposite ends of the artistic spectrum. On the one hand, he excelled in the species of stark realism exemplified by *Death and the Woodcutter*, which was modeled sometime before 1890 and subsequently lost, and also by another, slightly earlier, work known as *Mis-*

ery, a kind of counterpart to Rodin's *The Helmet-Maker's Wife*. On the other hand, from about 1890 onward, he made a number of attractive small-scale figures in the decorative style of Art Nouveau.[28] This attempt to break new ground in two categorically different areas bears a marked resemblance to the innovative efforts of Camille Claudel. The two artists knew one another well from their work in Rodin's studio.

A further similarity between Desbois and Claudel lies in the fact that they both failed to hear the call to modernity which was taken up and followed by other members of the generation born in or around the 1860s. One thinks, for example, of Bourdelle, Munch, Klimt, Stuck, Maillol, Toulouse-Lautrec, and Kandinsky. Unlike these artists, who made a clear choice in opting for symbolism and stylization, Desbois and Claudel hovered uneasily in the middle ground between naturalism, traditional academicism, and Art Nouveau. One should not seek to hold this against them; after all, they produced a number of very impressive single works. Yet they both lagged far behind the phalanx of young sculptors who were coming up to take Rodin's place. This is particularly striking in the case of Claudel, who was ten years younger than Desbois. In France, the first challenge to Rodin came from Maillol, Bourdelle, and Joseph Bernard (b. 1866), who were the same age as Claudel. They were followed by a group of somewhat younger sculptors, led by Charles Despiau, who quite abruptly liberated himself in about 1910 from the style of Rodin, his teacher and employer. Subsequently, an even younger generation emerged to carry sculpture forward into abstraction. Among the names that spring to mind are Duchamp-Villon (b. 1876), Henri Laurens (b. 1885), Alexander Archipenko (b. 1887), Constantin Brancusi (b. 1876), and Ossip Zadkine (b. 1890). Leaving aside the latter group, whose members are only mentioned here in order to sketch the general drift of later developments, this brief review of Claudel's approximate contemporaries may serve as an indicator of her inability to make a genuinely convincing contribution to the sculpture of her time and generation, before her creative energies finally evaporated in about 1907. The reasons for this are several and varied. In the first place, there was her close—perhaps too close—relationship with Rodin, from which she never really escaped, despite her attempts to bring about a radical separation when Rodin refused to accept the idea of a permanent liaison and destroyed her dream of marriage. Even after the final parting of the ways, Claudel remained deeply indebted to Rodin's art. She tried to distance herself from him, but he continued to supply the basic template for her work as a sculptor. Although the choice of theme and the handling of space bear her own personal mark, the naked figures in works such as *The Waltz*, *The Gossips* and *The Wave* still testify to her adoption of Rodin's approach to

Camille Claudel,
Little Girl with Doves,
1898

modeling. Secondly, Camille proved incapable of accepting and applying
the principle of stylizing reality instead of copying it. This is apparent not
only in her sculpture but also in her painting. Few examples of the latter
have survived, but they offer sufficient evidence to uphold the general ver-
dict. In 1898, for example, she painted a picture known as *Little Girl with
Doves,* showing a dead child on a beach, mourned by the white doves
referred to in the title. For all its bizarre beauty, this work demonstrates
Camille's preference for a toned-down version of Impressionism based
firmly on the study of nature. A mood of melancholy is conveyed by the
slightly simplified landscape, especially by the contrast between the gloomy
background and the brightness of the beach. This expressive touch can be
seen as beckoning in the direction of symbolism, with a certain hint of Art
Nouveau. There is a strange resemblance between the theme of the painting
and the account that Rodin later gave to Helene von Nostitz of an episode
in one of his dreams, parts of which accord exactly with the images in
Claudel's picture.

Camille Claudel was endowed with a keen critical intelligence that en-
abled her to comment astutely on the work of other artists. The soundness

of her judgment is exemplified by her favorable appraisal of Rodin's final model for his monument to Balzac in 1897. She must therefore have been in a position to assess the quality of her own work. In all probability, she recognized that she was incapable of making real progress and that she had failed to achieve the breakthrough which might have led to true creative independence after her separation from Rodin. Other women artists of the time—for example, Paula Modersohn-Becker (1876-1907) or Käthe Kollwitz (1867-1945)—had to contend with great material and psychological difficulties, but nevertheless succeeded in taking the crucial step that enabled them to find a convincing expressive idiom.

There is something touching about Camille's attempts to objectify her melancholy by portraying herself as a lonely woman waiting by the hearth and staring dejectedly into the flames. This motif is seen in three miniature

Camille Claudel,
*Deep Thought
(Woman Kneeling
before a Hearth)*,
1905

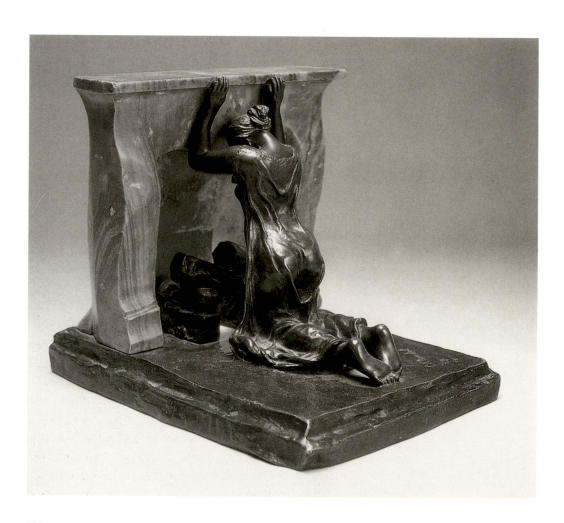

sculptures (the average height is approximately twelve inches), which are delicately executed but reminiscent of bric-à-brac: the figures are like "profound mantelpiece ornaments for lonely hearts." Such a view no doubt sounds cynical, and the sculptor's tragic fate makes one reluctant to say such things. Nevertheless, these works show, with frightening clarity, just how far Camille had traveled along the path of decline and isolation. And while the term "bric-à-brac" has pejorative connotations, it also touches on a positive side of her work—her tangential involvement in the revival, spearheaded by Art Nouveau, of the decorative arts. Once again, we find Camille experimenting with a variety of materials. The first of the figures, showing a young woman sitting on a chair by the fire, was executed in marble only. Made in 1903, it was donated in the same year by Alphonse de Rothschild to the Musée Municipal Draguignan. Two further versions followed in 1905, one in bronze and onyx and the other in bronze and marble. Both are now owned by private collectors. With or without the chair, the setting is faintly redolent of a doll's house.

It is impossible to imagine this piece as a full-scale sculpture. The figure clearly demonstrates that Camille would have done better to change tack at an earlier point in her career and concentrate her efforts on staying abreast of her contemporaries in the fields of miniature sculpture and applied art (one eschews the older term "handicraft," which has regrettably fallen out of fashion). The truth of this is underlined by the vague rumor that Camille spent her last years of freedom making various kinds of utilitarian objects. However, none of these artifacts have so far come to light. As a maker of small portraits, figures, and ornaments, she would probably have commanded more attention and greater esteem than by her attempts to compete with the leading artists of her day in sculpting on a monumental scale. *The Waltz*, too, is essentially a miniature. Seen in these terms, it is a fine piece of work with manifest positive qualities.

Especially in France, decorative artists often enjoyed a high reputation. This is clearly shown by the careers of some of Camille Claudel's contemporaries, such as Jules Desbois, who was widely esteemed as a maker of relief plates, bronze vessels and dishes decorated with ornamental figures. A further example of the same phenomenon is supplied by Rupert Carabin (1862-1932), a wood-carver from Saverne with an ordinary craftsman's training, who began exhibiting in 1884, at the same time as Camille Claudel and Jules Desbois, and whose work was regularly featured in the decorative arts section of the salon of the Société Nationale des Beaux-Arts. After gaining initial recognition with his furniture, decorated with carved figures on the legs and supports, Carabin won great acclaim for his statuettes in wax, wood, bronze, and his ornamental objects in various materials, including

amethyst and onyx, the semiprecious stone used by Claudel. Like Camille, Carabin was interested in the theme of dance, and he produced a well-known series of figures based on the movements of a dance performed with swirls of floating scarves by the prominent American artiste Loïe Fuller. He also made statuettes of passers-by, peasants, and sportsmen, dealing with everyday themes of the kind that Claudel programmatically espoused in her attempt to break free of Rodin. The difference being that, unlike Carabin, she was unable to carry out her plans. (It is interesting to note that Carabin's services to art were officially honored in 1918, when he was appointed director of the Strasbourg School of Art.)

These and other such comparisons are instructive, in so far as they reinforce the point that Camille failed to find her true niche. She halfheartedly recognized the opportunities afforded by the revival of the decorative arts under the banner of Art Nouveau, but at the same time she continued to dream of becoming a sculptor in the grand, public manner. This discrepancy inevitably led to her undoing as an artist.

Rupert Carabin,
Siren and
Octopus, 1900-1

The Gathering Shades

The story of Camille Claudel's declining years is familiar, and there is no need here to explore it in great detail. In 1893, Camille moved out of Rodin's studio and began to avoid his company. She still visited him now and then to seek his advice, but from 1895 onward, even these occasional meetings became rare. Rodin did everything in his power to win her back and to further her career by persuading others to exhibit and buy her work, and ensuring that it was favorably reviewed in the press. Far from welcoming these efforts, she reacted to them with increasing coldness and touchiness. In 1898, she broke off the relationship altogether, informing Rodin that she never wanted to see him again.

Three years previously, in 1895, Rodin had abandoned his workshop in the derelict Folie-Neufbourg and decided to look for more comfortable quarters outside Paris. In the same year he purchased the Villa des Brillants at Meudon. Here, in this large country house with its spacious gardens and splendid view of the Seine valley, he began to live the life of a truly successful and celebrated artist, especially after the resounding triumph of his exhibition at the 1900 World's Fair in Paris, where the central masterpieces from his vast oeuvre were shown in a separate pavilion and won the acclaim of the international public. Like Picasso in later years, Rodin was regarded as the exemplary artist of his day. Monarchs and aristocrats, captains of industry and finance, writers and intellectuals—they all flocked to his court and became his patrons and supporters. He received visits from King Edward VII of England and other such notables; George Bernard Shaw, Gustav Mahler, Clemenceau and Pope Benedict XV were among those who enlisted his services as a portraitist. Toward the end of his life, he was heaped with endless honors. His personal museum began to take shape in the Hôtel Biron, and he finally completed *The Gates of Hell*. When he died at the age of seventy-seven in November 1917, many people in the art world felt that his death marked the passing of an era.

In 1900 Camille Claudel gave up her studio on boulevard d'Italie and moved into a two-room apartment on the Ile St-Louis, right in the heart of Paris. Lack of money prevented her from renting larger premises, and although the apartment was beautifully situated, it was too small to serve as a proper sculptor's workshop. Nevertheless, financial assistance from patrons enabled her to execute *Perseus and the Gorgon* in marble and to cast the final version of *L'Age mûr* in bronze. She exhibited the two works, in 1902 and 1903 respectively, at the Salon of the Société Nationale des Beaux-Arts. The reaction of the critics was less than favorable.

In 1905 Camille again took part in the Salon, this time with a thirty-seven-inch-high marble version of *Sakuntala*, commissioned by the Comtesse de Maigret and titled *Vertumnus and Pomona*, together with *The Siren*, a retitled version of *The Flute Player*.

From 1900 onward, Camille showed an increasing tendency to utilize her earlier work—following a precedent set by Rodin—by taking individual figures out of existing groups, marginally altering their appearance, and giving them new titles. Thus, *The Implorer* reproduces the image of the kneeling young woman on the right of the group in *L'Age mûr*; *Fortuna* and *The Truth* are variants on *The Waltz*; and the figure in *Wounded Niobe* is the same as in *Sakuntala*, but without the male admirer. At this stage of her career, Camille produced no new work, apart from two busts (the last portraits of her brother Paul), which were made in 1905.

In about 1907, Camille's creative powers deserted her completely. Her behavior showed growing signs of paranoia, directed primarily at Rodin, whom she had come to hate with a singular intensity. Barricading herself in her apartment, which soon fell into a state of sordid neglect, she only went out at night.

A final pointer that may help to assess Camille's artistic standing is supplied by one of the last exhibitions of her work. In December 1905, the dealer and caster Eugène Blot organized a show featuring thirteen of her bronze sculptures, some of which were older pieces. An interesting feature of this display is the fact that Blot elected to couple it with an exhibition of bronzes by the German sculptor Bernhard Hoetger (1874-1949), who had been living in Paris since 1900. Hoetger had taken an enthusiastic interest in the work of Rodin, who had praised and encouraged him, and in the course of his relatively brief stay in Paris he made a large number of small bronze figures portraying manual laborers—dock workers, for example—and typical street characters such as beggars and blind people. These images were partly inspired by the semi-satirical form of social commentary found in the illustrations of Théophile Steinlen (1859-1923). In the work of Hoetger, Camille must have seen something very closely akin to the approach that she herself had intended to pursue. Was this perhaps one of the reasons why she despaired of her ability to carry out her own artistic program, and why, in 1906, she began systematically to destroy her plaster and clay models? Purchasers still showed an occasional interest in her work, and Blot held another, final, exhibition of eleven bronze sculptures in 1908. But to her friends and to observers of the Paris art world, it was obvious that her mental state was deteriorating. The symptoms of madness which had first manifested themselves in the 1890s were becoming ever more acute. Her brother Paul was deeply perturbed.

The Role of Paul Claudel in
His Sister's Drama

A certain amount of speculation has come to surround the part played by Paul Claudel in the drama of Camille's life, and there is good reason to believe that his role was far from clear-cut. Camille had a very deep affection for her younger brother: "my little Paul," as she still called him long after he had reached adulthood. During his schooldays, she had directed his interest toward artistic matters and inspired him to write. He also drew on her character as a model for some of the figures in his novels and plays. The features are partially disguised but nonetheless clearly recognizable.[29]

From the 1890s onward, as Camille's derangement became increasingly apparent, the relationship between brother and sister inevitably grew somewhat strained. In January 1890, doubtless at Camille's request, Rodin intervened on Paul Claudel's behalf by writing a letter of recommendation to the French foreign minister Eugène Spuller—a personal acquaintance—to smooth the path for the young man's future career by ensuring that his name was entered on the list of candidates for the entrance examination to the diplomatic service. It seems that Paul never thanked Rodin for this gesture of support, although it had the desired effect. Like his parents, he sharply disapproved of his sister's liaison with the master sculptor. Many years later, after Camille's incarceration in Montdevergues, her mother told her in an angry letter how shocked she had been by the discovery, when Rodin and Rose Beuret visited Villeneuve, that the couple had been living together without a marriage certificate; and then, when it transpired that Rodin was also conducting an affair with Camille, her mind was made up. In her eyes, such a relationship was scandalous, sinful, unthinkable.

In 1900, during the Christmas celebration of mass at Notre-Dame Cathedral, Paul Claudel received a divine revelation, and from this moment on he adopted a quite fanatical religiosity. He continually proselytized his family and friends and tried to persuade them to return to the traditional pieties of the Catholic faith. André Gide, a former schoolmate and a lifelong victim of his missionary zeal, once remarked that Paul was "demolishing his old friendships with a monstrance."

During the 1890s, Claudel spent much of his time overseas, pursuing his diplomatic career. When he returned temporarily to Paris in 1895, he invited the writer Jules Renard, who was the same age as Camille, to dine with the family. In his diary, Renard painted a grim psychological portrait of Paul and Camille. With her face powdered white like a blank mask, Camille kept losing her temper and bursting out in sudden tirades, scream-

ing at the top of her voice that she hated music and accusing Renard of planning to hold her up to public ridicule in his next book. Paul, meanwhile, was silently furious, his head bent low over the table as he trembled with despair and shame at his sister's conduct.[30]

In the same year, Rodin used his influence to persuade the writer and critic Octave Mirbeau to publish an article praising Camille's work. Mirbeau obliged by describing her as a woman of genius who was nevertheless unable to make a living from her art: she had therefore grown discouraged and was suffering from depression. Rodin also asked Mirbeau to arrange a meeting with Camille, whom he had not seen for the past two years. At her request, he had even stopped writing to her. The encounter, at Mirbeau's apartment, did nothing to defuse the tension. This was the year in which Rodin moved to his new rural retreat in Meudon, where he once more set up home with Rose Beuret. According to later reports, Camille sulked around the gardens at Meudon and hid in the shrubbery to watch Rodin coming home from work—a truly harrowing image.

Rodin tried all kinds of stratagems to help her, but his efforts were in vain. In 1896, for example, when he sent her an invitation to the opening of the Salon at the Champ-de-Mars, she responded with a telegram sarcastically thanking him for his offer to present her to the President of the Republic (who usually opened the exhibition but did not necessarily greet all the artists). However, she added, she was unable to attend the occasion, as she had nothing suitable to wear. She used this excuse on a number of other occasions when declining invitations. After the final break, the artist she once loved became the target of her hatred and the main object of her paranoid delusions. She also accused other people of spying on her as Rodin's "agents" and trying to break into her apartment.

In 1905 Paul Claudel published an article about his sister in the journal *L'Occident*. This was a grotesque—yet at the same time, touching—attempt to affirm her reputation as an artist in her own right, by comparing her with Rodin, whom Claudel nevertheless avoided mentioning by name. Rodin was said to be "the heaviest, most materialist" of sculptors, whose provocatively erotic figures "thrash about in the mud." Camille, on the other hand, was characterized as a woman of sublime imagination and inspiration. Her brother's unpublished writings include a further essay, dating from the same period, in which he vented his spleen directly on Rodin, describing him as a boorish lout, fit only to be a studio assistant.[31] Paul later stepped up his attacks on Rodin, whom he held responsible for his sister's unhappiness. But for the meantime, his work took him away from the scene of the continuing story, which was rapidly turning into a full-blown scandal.

Paul Claudel with a
bust of his sister, 1955

Although he was fond of Camille to the point of idolizing her, Paul Claudel was also critical of his sister. In his memoirs, he described how, even as a young girl, she dominated the entire family with her "often cruel influence." When she later fell on hard times, beset by financial and psychological problems, the other members of the family seemed to exact revenge by closing ranks and virtually ostracizing her. Only her father continued to sympathize with her and helped her by giving her money and sending her occasional gifts.

In a letter to Paul, written at some point after 1907, Camille alleged that a servant had spiked her coffee with some form of narcotic drug which had sent her to sleep for twelve hours. On waking, she found that the woman had stolen various things from her apartment, including a sculpture, *Woman with Cross*, three copies of which had subsequently turned up in various galleries. Thus, she wrote, "the crooks have profited to the tune of 100,000 francs." Once again, she railed against Rodin: "The unsavory individual exploits me wherever he can, and shares the proceeds with his fashionable artist cronies, who pay him back with medals and ovations,

banquets, etc. The ovations for this famous man have cost me the shirt off my back, and I get nothing, absolutely nothing."[32]

Diatribes of this kind became a common feature of Camille's behavior. She leveled wild accusations at the Huguenots and other obscure enemies, and continually heaped imprecations on Rodin, who was supposedly growing rich by stealing her work and at the same time "cutting off my livelihood, leaving me penniless."[33] She even accused Rodin of secretly plundering the Louvre. In between such outbursts, she would relapse into listless apathy, wandering endlessly through the streets of Paris at night and observing the beggars. Now and again, when she had a little money, she threw impromptu parties on the bank of the Seine, attended by a random assortment of the oddest characters. She neglected her personal appearance and her small studio household; and people suspected her of having turned to drink. Her financial difficulties led her to write begging letters to her family. Her father continued to send her money, but this was kept secret, since her mother was appalled by her moral and material decay and wanted nothing more to do with her. Paul also gave her small sums of money from time to time; and Rodin continued his vain efforts to obtain a state commission for her.

Paul Claudel grew increasingly concerned about his sister's behavior. Like the rest of the family, he was worried about the potential consequences for their collective reputation. This was doubtless an important point, not only to his mother, with her conservative, bourgeois outlook, but also to his younger sister, Louise, and to Paul himself, as a rising young diplomat who did not want his career impeded by scandal. The devout Catholic asked the Abbé Fontaine, a friend and confidant, whether it might be possible to perform an exorcism in absentia, to drive out the demons which had taken possession of Camille's spirit. "Her voice," Paul wrote, "had changed completely....She ... lives with the doors and windows locked in a really disgustingly filthy apartment."[34]

On March 2, 1913, Louis-Prosper Claudel died. He was buried two days later in Villeneuve; Camille was not invited to the funeral or even informed that her father had passed on. Now that her main protector was removed from the scene, her mother and brother were finally in a position to implement a radical solution to the problem, which in their eyes was rapidly getting out of hand. As his letter to the Abbé Fontaine indicates, Paul Claudel had probably been thinking for some time of having his sister committed to an asylum. On March 5, immediately after the funeral, Paul applied for the medical certificate required by law to initiate the internment proceedings. Two days later, he went to see the director of the Ville-Evrard hospital near Paris. The director advised him that it would be necessary to

have the certificate amended, which delayed events by a further couple of days. On Monday, March 10, a week after her father's death, Camille was dragged from her apartment by two warders, bundled into a waiting vehicle and transported off to the asylum. In his diary, Paul wrote that he felt "quite miserable." Nevertheless, he was evidently convinced that he had done the right thing: for his sister, whom he loved but also feared, there seemed to be no other way out.

Shortly after this episode there was an outcry in the press concerning Camille's forcible removal and incarceration. Criticisms were made of the antiquated law which made it all too easy for anyone who had become an inconvenience to be taken out of circulation and locked away. The finger of accusation was also pointed at the Claudel family, especially at the son who was its new head. Paul Claudel was called upon to explain the matter to the public, which was growing increasingly concerned about "crimes" of this kind.[35] A newspaper article of December 20, 1913 claimed that Camille Claudel, though sound in mind and body, had been arrested without a warrant by three men who had forced their way into her apartment and hauled her off to Ville-Evrard. Paul Claudel, who had only recently been appointed consul general in Hamburg, did not reply to these accusations. His professional position would no doubt have prevented him from making a public statement. His private response is documented by a remark in his diary which shockingly blends self-serving smugness with cynicism: "I have so often been praised unjustly that slander makes a welcome and refreshing change. This is a Christian's normal fate."[36]

Before the outbreak of the First World War, Rodin attempted in vain to visit Camille at Ville-Evrard. In September 1914 she was transferred to the Montdevergues psychiatric hospital near Avignon in the South of France, far away from Paris.[37] There she remained, in close confinement, until her death on October 19, 1943, a few weeks before her eightieth birthday. The length of her incarceration amounted to over thirty years.

Neither her mother nor her sister ever came to see Camille, although she continually wrote begging them to do so. Paul Claudel did pay occasional visits, however, and saw her again shortly before she died, despite the difficulties involved in traveling across German-occupied France. Her old friend Jessie Lipscomb also visited her at Montdevergues, and she and her husband came away with the impression that Camille was definitely not insane. However, it is well-known that paranoia tends to follow an episodic pattern. Severe bouts of derangement alternate with phases of relative normality. The abrupt changes in Camille's mental state are documented in her letters to her mother and brother, and to several other people. These letters have since been published. To read them is to gain a

harrowing insight into the nethermost depths of human suffering. In the 1920s, the doctors at Montdevergues suggested releasing Camille into the custody of her family, but her mother rejected the proposal out of hand. On no account did she want Camille back in her house. She was desperately afraid that her daughter might suffer a relapse and cause renewed scandal.

From Idol to Sphinx: Camille in the Eyes of Rodin

Even after the final separation, Rodin's affection for Camille persisted. He used her portrait in *St. George* and *La France* (1904), where the head is topped with a helmet. This study then formed the basis for the bronze bust in three-quarter relief and for the stone version of his monument, unveiled in 1912, to the French explorer Champlain, the founder of Quebec and discoverer of the lake that bears his name. Rodin also made a bust of Camille in pâte-de-verre, based on the early portrait of her wearing a Breton-type cap which had served as the model for *The Thought*. The recipe for pâte-de-verre had recently been rediscovered by Henri Gros, whose son, Jean, did the molding of the figure for Rodin in 1911. This material, with its pale, opaque appearance, may well have acted as a particularly poignant reminder of Camille's melancholy and gradual decline. Several accounts testify to the emotional effect of the separation on Rodin, who was shocked and deeply hurt when Camille made the final break. He would have been happy to continue the ménage à trois with her and Rose, who occupied an entirely separate area of his life. Between 1908 and 1912, he lived with the Duchesse de Choiseul in the Hôtel Biron, while Rose looked after the household in Meudon, and he probably imagined that it might be possible to sustain such an arrangement with Camille. After all, his affair with her had been conducted on similar terms during the years they had spent secretly cohabiting at the Folie-Neufbourg. But Camille was not prepared to share the limelight with another woman on a permanent basis. She continually badgered Rodin to decide, once and for all, where he stood. The solution she envisaged is clearly indicated by the private "contract" of 1886. Six years later, having concluded that Rodin had not fulfilled his part of the bargain, she decided to leave him. Subsequently she wavered and almost returned several times, but eventually the split became final.

Rodin evidently continued to hope that she would relent, although his desire for a reconciliation weakened as the years wore on. After the terrible

Auguste Rodin,
La France, 1904

rows that had been a continual feature of their relationship, and especially
in view of Camille's increasingly wild, imperious manner and incipient de-
mentia, he doubtless found the idea of marriage less and less appealing.
With the typical egocentricity of the true artist, he sought to avoid anything
that might disturb the atmosphere of tranquil harmony required by his
work.

It has sometimes been said that Rodin's own creative powers were ex-
hausted after the break with Camille, and that he never again managed to
produce anything of real significance. This is patently absurd. His monu-
ment to Balzac, for example, which he abandoned after many years of strug-
gle in 1897 or 1898, is rightly seen as a groundbreaking masterpiece. No
one less than Constantin Brancusi (1876-1957) said that it represented the
beginning of modern sculpture. During this latter period of his life, Rodin
also sculpted a number of major portraits, including his busts of Gustav
Mahler and Clemenceau; and his use of the torso in *The Walking Man* and

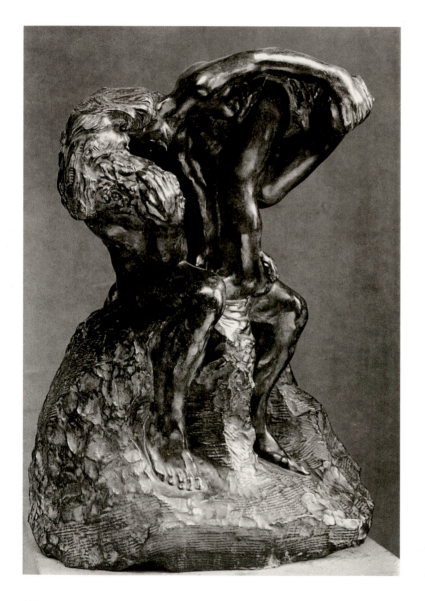

Auguste Rodin,
*The Sculptor and
His Muse*, 1890

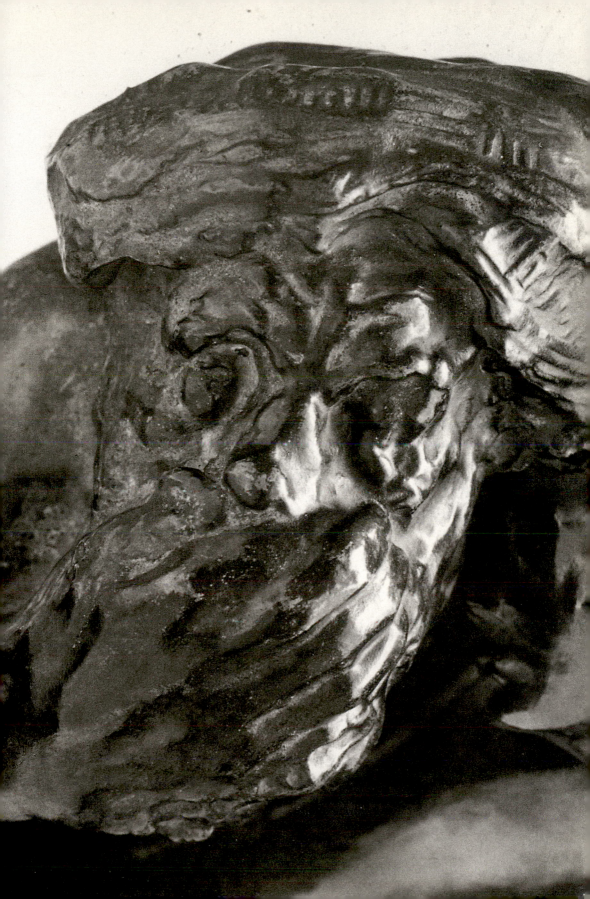

Auguste Rodin, *Two Women Embracing*, 1911

in various female statues was to inspire future sculptors. A further feature of his later work is his astonishing productivity as a draftsman.

In conclusion, let us look at one more sculpture by Rodin that illustrates his point of view regarding the relationship with Camille—an aspect which has not been given sufficient consideration in previous accounts of the case. The work in question is *The Sculptor and His Muse*, sometimes referred to as *The Sculptor's Dream*. Here, Rodin addresses the familiar theme of the relationship between the artist and his creative inspiration, personified in the figure of the Muse. This is a commonplace of nineteenth-century sculpture, but Rodin gives it an unusual twist by portraying the encounter as almost tragic. The figure of the sculptor is a

disguised portrait of the master himself, based on the head of the *Man with the Broken Nose*, which Rodin often used when referring to his own person.[38] The latter work originally dates from 1863-64, round about the time when Rodin first met Rose Beuret. In *The Sculptor and His Muse*, he depicts himself in a Michelangelesque pose that also recalls the statue of *The Thinker*, as a naked, athletic figure whose mood of contemplation is threatened by the attentions of the Muse. She, a graceful young woman who has seemingly just descended out of the blue, is standing literally on top of him, with one foot on his thigh and her face nuzzling his ear and left temple; her flowing hair is falling about his face, and the two heads appear almost to merge into one. This makes it difficult to say with certainty whether the Muse's face is a further idealized portrait of Camille. With her left hand, the figure is holding her right foot, which is bent back in a complex, almost balletic movement, while her right hand gropes down toward her other foot, lodged in the sculptor's lap—a bold and unambiguously erotic gesture. Twisting his body away to one side to resist the tempestuous embrace of his importunate Muse, the old man is sitting with one hand clapped to his mouth, as if to suppress a cry of horror. His facial

Auguste Rodin,
Salammbô, ca. 1900

expression clearly betokens fear and anguish. This group was probably made *before* Camille produced her symbolic interpretation of the same relationship in *L'Age mûr* and *Perseus and the Gorgon*. At all events, the work is clearly a sculptural rendering of the maelstrom of conflicting emotions that beset Rodin at the time of the couple's parting, which caused him great pain. As Edmond de Goncourt reported, Rodin was even seen to burst into tears on one occasion. It also no doubt refers to the storms of the past and the never-ending war of nerves with Camille while the liaison was still continuing. Camille had inspired Rodin to create some of his most majestic and enduring sculptures, and, looking back at the relationship, he must have been aware that she was the last of his grand *amours*.[39]

When Rilke first saw *The Sculptor and His Muse* at Meudon in 1902, he had no inkling of the context that had shaped the work. His brief exchange with Rodin produced the following remark, which, in the light of what we now know, takes on a tragic poignancy. In his 1903 study of the sculptor, Rilke wrote: "Rodin, incidentally, is silent, like all men of action. He seldom allows himself the privilege of clothing his insights in words, since this is the preserve of the poet; and in his modest view the poet ranks far above the sculptor. As he once said with a resigned smile when looking at his beautiful group *The Sculptor and His Muse*, 'the sculptor, slow-witted as he is, has to make an extraordinary effort to understand the Muse.'"[40]

For Rodin, as for many other sculptors of his day, the concept of the Muse had a double significance. On the one hand, there was the ideal Muse, an allegorical figure that stood for the lofty notion of "inspiration," while on the other, there was her real equivalent, an actual flesh-and-blood woman whose appeal and influence were of a direct, mainly sensual, nature. Camille Claudel played both these roles at once. For several years, she was Rodin's ideal *and* real Muse. But in time, she became ever more sphinx-like—hence the remark to Rilke about the enigma of inspiration.

There is no point in trying to pin the blame for the outcome of this real-life drama on any of the individual actors. Rodin could not have been expected to abandon Rose in order to marry a younger woman, nor could Camille's mother and brother have welcomed her back into the bosom of the family. As well as offending their prejudices, her madness genuinely frightened them. Nor, indeed, would it have been realistic to expect Camille to limit herself to making small sculpture and decorative ornaments in order to earn a conventional living. Her pride, her ambition, and her illness stood in her way and made such a solution inconceivable. Thus, the tragedy took its inevitable course.

Auguste Rodin, *Cambodian Dancer*, 1906

AUGUSTE RODIN

1840　Born on November 12 in Paris

1854　Attends the Ecole des Arts Décoratifs, Paris

1864　Rodin's first encounter with Rose Beuret, his lifelong mistress and companion

1866　Birth of illegitimate son, Auguste Beuret

1871　Works in Brussels as an ornamental sculptor

1875　Travels to Italy for the first time

1880　First major state commission, for *The Gates of Hell*

1883　Takes over the role of instructor to the circle of young women sculptors headed by Camille Claudel. *Portrait of Victor Hugo*

1884　Commission for *The Burghers of Calais*. Beginning of affair with Camille Claudel. Rodin sculpts the first of several portraits of his new mistress

1886　Travels to England in pursuit of Camille

1891　Commission for *Balzac*

1893　Elected president of the sculpture section of the Société Nationale des Beaux-Arts

1895　Moves to the Villa des Brillants at Meudon, outside Paris

1902　Major exhibition in Prague

1906　Unveiling of *The Thinker* in front of the Panthéon

1912　Exhibition at The Metropolitan Museum of Art, New York

1913　Tries, without success, to visit Camille at the psychiatric hospital to which she has been consigned

1916　Rodin bequeaths his entire fortune and all his remaining works to the French state

1917　Marriage on January 29 to Rose Beuret, who dies just over two weeks later. On November 18, Rodin himself dies, aged seventy-seven, at Meudon

1919　Opening of the Musée Rodin

CAMILLE CLAUDEL

1864　Born on December 8 in Fère-en-Tardenois

1868　Birth of brother, Paul Claudel, later to become a diplomat and noted poet

1870　Claudel family moves to Bar-le-Duc

1876　Family moves again, this time to Nogent-sur-Seine

1879　Camille Claudel receives her first lessons in modeling from the sculptor Alfred Boucher

1881　Family moves to Paris. Camille studies at the Académie Colarossi, a private art school, and joins a group of young women sculptors

1885　Works as an assistant in Rodin's studio

1886　Camille travels to England, following the first of many crises in her relationship with Rodin

1888-89　First important exhibition with *Bust of Auguste Rodin* and *Sakuntala*

1891　Serves as member of the panel judging the entries for the exhibitions of the Société Nationale des Beaux-Arts. Travels to Touraine with Rodin

1893　Creates *The Waltz* and *Clotho*. Moves out of Rodin's studio

1896　Sculpts the first version of *L'Age mûr*. Begins to show signs of severe derangement

1898　Final break with Rodin. Financial problems

1905　Travels for the last time with Paul to the Pyrenees

1906　Bouts of persecution mania. Camille increasingly shuts herself off from family and friends

1908　Last exhibition at the gallery of Eugène Blot

1913　On March 10, shortly after her father's death, Camille is forcibly removed to the Ville-Evrard mental hospital near Paris

1914　Transferred to the asylum at Montdevergues in the south of France

1943　Camille dies on 19 November at Montdevergues

1951　First posthumous retrospective at the Musée Rodin

Notes

1 J.A. Schmoll gen. Eisenwerth, "Rodins Ehernes Zeitalter und die Problematik französischer Kriegerdenkmäler nach 1871," in *Der politische Totenkult*, ed. Karl E. Jeismann and Reinhart Koselleck (Munich, 1994).

2 J.A. Schmoll gen. Eisenwerth, "Rodins Höllentor," in *Auguste Rodin –Das Höllentor*, ed. Manfred Fath in collaboration with J.A. Schmoll gen. Eisenwerth (Munich, 1994), pp. 13-46; and Albert E. Elsen in *The Gates of Hell by Auguste Rodin* (Stanford, 1985).

3 Frederic V. Grunfeld, *Rodin: A Biography* (New York, 1987), p. 215. Although I do not agree with F.V. Grunfeld on every point, I am indebted to him for much of the information in my account (see chapter 9, "Rodin in Love," pp. 211-43) in his extensively researched biography.

4 Ibid.

5 Ibid., pp. 215-16.

6 Ibid., p. 217.

7 Ibid., pp. 558 ff.

8 An example of the way in which the emphasis on Claudel's importance can be taken to grotesque extremes is to be found in Barbara Krause's novel *Camille Claudel– Ein Leben in Stein* (Freiburg, Basle, Vienna, 1993). The author claims that Camille gave Rodin the idea of making a group of six figures—instead of a single statue—for *The Burghers of Calais* and that she was the dominant partner in the conception of other major projects, including the monument to Balzac and *The Gates of Hell*. In the case of the latter, Krause asserts that Camille was the true originator of the "living relief" structure.

9 See Ursula Heiderich, *Die Skulpturen in der Bremer Kunsthalle* (Bremen, 1993), pp. 150 ff.

10 The full text of the letter is reproduced by permission of the Musée Rodin in the exhibition catalogue *Camille Claudel*, ed. Renate Berger (Hamburg, 1990), p. 111. Neither Grunfeld nor Jacques Cassar (*Dossier Camille Claudel*, Paris, 1987) was familiar with this strange document; nor do we know whether Camille Claudel actually received the letter, which may be the original or merely a copy that Rodin kept for reference.

11 *L'Art*, vol. II (Paris, 1886), p. 67.

12 See Nicole Barbier, *Marbres de Rodin. Collection du Musée* (Paris, 1987), pp. 92 ff.

13 Rodin was superficially acquainted with the pessimism of Schopenhauer, and later—long after the art works in question were made—acquired some passing knowledge of the ideas of Nietzsche and Bergson. However, the work of writers such as Victor Hugo, Alfred de Musset, and Charles Baudelaire had a far deeper impact on his thinking. See the comments of Grunfeld, passim, and, especially, the exhibition catalogue *Rodin et les écrivains de son temps*, ed. Catherine Lampert and Claudie Judrin (Paris, 1976). Although reading was important to Rodin, his work was primarily based on experience and intuition.

14 The bronze cast of *The Thought* in the Rodin Museum, Philadelphia, clearly shows how unsuited this material was to Rodin's aesthetic and symbolic purposes, which specifically required the use of marble. See John L. Tancock, *The Sculpture of Auguste Rodin. The Collection of the Rodin Museum Philadelphia* (Philadelphia, 1976), p. 589.

15 See Grunfeld (note 3), p. 218. Grunfeld's account of this aspect of the affair is based on Jessie Lipscomb's letters and documents, owned by Mr. R.E.M. Elborne, London.

16 Letter of March 15, 1887, quoted by Grunfeld, p. 218. The letter is reproduced in Cassar (note 10), p. 71.

17 See Grunfeld (note 3), p. 222, and Paul Claudel, *Œuvres en prose*, (Paris, 1965), p. 279.

18 See *Auguste Rodin–Zeichnungen und Aquarelle* (ex. cat. Münster), ed. E.-G. Güse (Stuttgart, 1984), pp. 96, 117; and Claudie Jurin, *Inventaire des Dessins. Musée Rodin Paris* (Paris, ca. 1990) vol. V, no. 7102, p. 285 and color plate. Jurin gives the date as "vers le 11. Nov. 1898," with no further explanation.

19 Grunfeld (note 3), pp. 224 f.

20 Ibid., p. 230.

21 See Theo Hirsbrunner, *Debussy und seine Zeit* (Laaber, Germany, 1981), p. 18, passim; and Edward Lockspeiser, *Debussy–His Life and Mind* (London, 1962), vol. I, p. 183.

22 *Nancy 1900–Jugendstil in Lothringen zwischen Historismus und Art Déco*, ex. cat. Stadtmuseum München 1980-81, ed. Helga and J.A. Schmoll gen. Eisenwerth, (Mainz, Murnau, 1980), No. 366, pp. 338 ff. See also *La sculpture française au XIXe siècle*, ex. cat. Grand Palais, Paris, ed. Anne Pingeot (Paris, 1986), No. 237, p. 383.

23 There has been some discussion about the priority of Rodin's *Helmet-Maker's Wife* vis à vis *Misery*, a naturalistic study made in 1890 by Desbois. See J.A. Schmoll gen. Eisenwerth, "Tritt der Bildhauer Jules Desbois (1851-1935) durch Beiträge zum Realismus und zum Jugendstil aus dem Schatten Rodins?" in *Festschrift für Peter Bloch*, ed. H. Krohm and C. Theuerkauff (Mainz, 1990), pp. 337-46 (with a reproduction of Desbois' *Death and the Woodcutter*).

24 Rodin's original title for *The Centauress* was *L'Ame et le Corps* (Body and Soul). This is an obvious reference to the philosophical question of the duality of human existence—an issue first explored by Plato and summed up by Nietzsche in the dictum: "Man is the sick animal." See also Michael Kausch, "Symbol, Psyche und Gesellschaft. Untersuchungen zur semantischen Struktur des Werkes von Auguste Rodin," Ph.D thesis, Univ. Innsbruck (1993). I would like to take this opportunity of thanking the author for permitting me to read his manuscript.

25 See Georges Grappe, *Catalogue du Musée Rodin*, 5th ed. (Paris, 1944), No. 239, No. 82 f.; Tancock (note 14), No. 20, p. 200 ff.; Barbier (note 12), pp. 242 ff.

26 Anne Pingeot (note 22) mentions the very similar kneeling figure in Ferdinand Hodler's painting *La Communion avec l'infini*, now in the Kunstmuseum Basel, which was exhibited for the first time at the 1893 Paris Salon. For a general

treatment of the subject, see Pingeot's essay "Le chef d'œuvre de Camille Claudel: L'Age mûr," in *Revue du Louvre* No. 4 (1982), pp. 287-95; and *L'Age mûr de Camille Claudel*. Les Dossiers du Musée d'Orsay 25, ed. Anne Pingeot (Paris, 1988).

27 *Claude Monet–Auguste Rodin. Centenaire de l'exposition de 1889*, ex. cat. Musée Rodin, Paris (Paris, 1989-90), No. 40, pp. 202 ff. The work is titled *La Vague* (The Wave) or *Le Flot; la grève* (The Waves, the Shore). The exhibition of 1889 also included the group known as The Sirens.

28 See note 23.

29 See Bernard Howells, "Le bouclier-en-mirroir de Persée. Postface sur la trace de Camille Claudel dans l'oeuvre de son frère" in Reine-Marie Paris, *Camille Claudel: 1864-1943* (Paris, 1985), pp. 313-51.

30 See Grunfeld (note 3), p. 234.

31 Ibid., p. 239.

32 See Reine-Marie Paris (note 29), pp. 122 f.

33 In a letter written before 1910. Ibid., p. 124.

34 Grunfeld (note 3), p. 240.

35 Paris (note 29), pp. 91 f.

36 Ibid., p. 92.

37 At the beginning of September 1914, the region around Paris was under threat from the German army. The decision to move Camille to Montdevergues may have had something to do with this, but the truth of the matter is uncertain.

38 See J. A. Schmoll gen. Eisenwerth, "Rodins 'Le Masque de l'Homme au nez cassé,'" in *Rodin-Studien*, ed. J. A. Schmoll gen. Eisenwerth (Munich, 1983), pp. 163-214.

39 On the bronze copy of *The Sculptor and His Muse* in the Kunsthalle Bremen, see Heiderich (note 9), pp. 378 ff.

40 Rainer Maria Rilke, *Auguste Rodin* (Leipzig, 1913), p. 108.

Asselin, Henry. "Camille Claudel et les sirènes de la sculpture." *Revue française*, no. 187 (1966), pp. 8-12.

Asselin, Henry. "La vie douloureuse de Camille Claudel, sculpteur." Radio lecture, 1956. Ms. Paris, Bibliothèque Nationale, Fonds Claudel.

Camille Claudel. Exhibition cataloque. Musée Rodin, Paris, 1951.

Camille Claudel. Exhibition catalogue. Ed. Monique Laurent and Bruno Gaudichon. Musée Rodin, Paris, and Musée Sainte-Crois, Poitiers, 1984.

Camille Claudel. Exhibition catalogue. Fondation Pierre Gianadda, Martigny, Switzerland, 1990-91.

Camille Claudel–Auguste Rodin. Künstlerpaare–Künstlerfreunde. Exhibition Catalogue. Kunstmuseum, Bern, 1985.

Camille Claudel. 1864-1943. Skulpturen–Gemälde–Zeichnungen. Exhibition catalogue. Ed. Renate Berger. Festival der Frauen und BATIG-GmbH. 2d ed., rev. and exp. Hamburg, 1990.

Cassar, Jacques. *Dossier Camille Claudel.* Paris, 1987.

Claudel, Paul. "Ma sœur Camille." In *Œuvres en prose.* Paris, 1965. Reprinted in *Camille Claudel.* Exhibition catalogue. Musée Rodin, Paris, 1951.

Delbée, Paul. *Une Femme.* Paris, 1982.

Exposition d'Œuvres de Camille Claudel et de Bernard Hœtger. Exhibition catalogue. Galerie Eugène Blot, Paris, 1905.

Flagmeier, Renate. "Camille Claudel, Bildhauerin." *Kritische Berichte* I (1988), pp. 36-45.

Grundfeld, Frederic V. *Rodin: A Biography.* New York, 1987.

Krause, Barbara. *Camille Claudel. Ein Leben in Stein.* 3d ed. Freiburg, 1993

Morhardt, Mathias. "Camille Claudel." *Mercure de France*, March 1898. Reprinted in vol. 25 (Vaduz, 1965), pp. 709-55.

Paris, Reine-Marie. *Camille Claudel.* Paris, 1984.

Paris, Reine-Marie. *Camille Claudel.* Exhibition Catalogue. The National Museum of Women in the Arts, Washington, D.C., 1988.

Pingeot, Anne. "Le chef-d'œuvre de Camille Claudel: L'Age mûr." *Revue du Louvre et des Musées de France*, no. 4 (October 1982), pp. 287-95.

Pingeot, Anne. *"L'Age mûr" de Camille Claudel.* Les Dossiers de Musée d'Orsay, 25. Paris, 1988.

Rivière, Anne. *L'Interdite. Camille Claudel 1864-1943.* Paris, 1983. (Made into a film, starring Isabelle Adjani and Gérard Depardieu. Premiere in Paris, 1988.)

Schmoll gen. Eisenwerth, J.A. *Rodin-Studien. Persönlichkeit–Werke–Wirkung–Bibliographie.* Munich, 1983. (With a complete bibliography up to 1982.)

Schmoll gen. Eisenwerth, J.A. "Camille Claudel and Rodin." Lecture held September 21, 1984. In *Epochengrenzen und Kontinuität–Studien zur Kunstgeschichte.* Ed. Winfried Nerdinger and Dietrich Schubert. Munich, 1985. (*Auguste Rodin and Camille Claudel* is a revised and expanded version of this lecture.)

Schweers, Andrea. "Camille Claudel 1864-1943. Begegnung mit einer Vergessenen." In *Wahnsinnsfrauen.* Ed. Sibylle Duda and Luise F. Pusch. Frankfurt am Main, 1992.

Vauxcelles, Louis. "A propos de Camille Claudel. Quelque œuvres d'une grande artiste inconnue du public." In *Le Gil Blas*, July 10, 1913.

The Flute Player
(The Little Siren) 1904
*La Joueuse de flûte
(La Petite Sirène)*

Bronze
20⁷/₈ x 10⁵/₈ x 9¹/₂ in.
(53 x 27 x 24 cm)
Private collection
Page 100

Sakuntala

Plaster 1888, marble 1905
37³/₈ x 32¹/₄ x 9¹/₂ in.
(95 x 82 x 40 cm)
Musée Rodin, Paris
Page 44

Deep Thought (Woman
Kneeling before a Hearth) 1905
*Profonde pensée (Femme
agenouillée devant une
cheminée*

Bronze and onyx with small light
9¹/₂ x 8⁵/₈ x 10⁵/₈ in.
(24 x 22 x 27 cm)
Private collection
Page 104

Portrait of Louis-Prosper
Claudel 1905
*Portrait de Louis-Prosper
Claudel*

Crayon
22⁷/₈ x 18⁷/₈ in. (58 x 48 cm)
Private collection
Page 11

WORKS BY OTHER ARTISTS

Donatello,
Mary Magdalene ca. 1453-55
Wood
Height: 74 in. (188 cm)
Museo dell'Opera del Duomo,
Florence
Page 73

Ligier Richier, statue of Death
from the monument to René de
Châlons in the Eglise St. Pierre
in Bar-le-Duc after 1544
Limestone
H.: 68⁷/₈ in. (175 cm)
Page 73

Middle-Aged Man and His Two
Mistresses
*L'Homme entre deux âges et
ses deux maîtresses*

Engraving taken from an
eighteenth-century French almanac
Page 85

Victor Prouvé, The Night 1894
La Nuit

Bronze
18¹/₈ x 31 x 18⁷/₈ in.
(46 x 79 x 48 cm)
Musée de l'Ecole de Nancy, Nancy
Page 72

Jules Desbois, Misery 1896
La Misère

Wood
Musée des Beaux-Arts, Nancy
Page 77

Rupert Carabin, Siren and
Octopus 1900-1
Sirène et pieuvre

Bronze and onyx
H. including base: 11³/₈ in. (29 cm)
Page 106

PHOTOGRAPHS

Auguste Rodin ca. 1880
Page 8

Camille Claudel ca. 1884
Photograph by César
Page 6

Camille Claudel in Rodin's
studio working on *Sakuntala*
Photograph by Lipscomb (?)
Musée Rodin, Paris
Page 2

Auguste Rodin ca. 1885
Page 9

Claude Debussy, Rome 1885
Page 69

Camille Claudel 1886
Photograph by Etienne Carjat
Robert Elborne Collection
Page 37

Auguste Rodin ca. 1886
Photograph by Bergerac
Page 55

The Claudel family on the
balcony of their apartment on
Boulevard de Port-Royal 1887
Robert Elborne Collection
Page 15

La Folie-Neufbourg, the
eighteenth-century house
rented by Rodin in 1888
Page 59

Camille Claudel at work on her
plaster maquette of *Perseus and
the Gorgon* ca. 1898
Page 95

Paul Claudel with a bust of his
sister 1955
Bibliothèque nationale, Paris
Page 111